Exploring Visual Design

Elements of Design

Large Reproductions

Teacher's Guide

Davis Publications, Inc., 50 Portland Street, Worcester, MA 01608

Publisher: Wyatt Wade
Editorial Director: Helen Ronan
Production Editor: Carol Harley
Manufacturing Coordinator: Jenna Sturgis
Editorial Assistance: Colleen Strang
Copyeditor: Kevin Supples
Design: Douglass Scott
Page Production: Matt Mayerchak

Contributing Editor
Sallye Mahan-Cox

Printed in the United States of America
ISBN: 87192-381-5
10 9 8 7 6 5 4 3 2 1

Acknowledgements

My thanks go to the many artists and experts who shared their time, expertise, and working secrets with me for this project. My daughter, Emma, saw me through all this and was forever ready to help. I am humbled and challenged by her faith in me, and grateful for her encouragement. Nicholas' profound understanding of what it means to pursue a professional life of achievement gives me the freedom and support to take on challenges like this project. I am thankful for his wisdom and encouragement. Helen Ronan, the editor of this series, provides support, great freedom to explore ideas, challenges, and the necessary prodding to keep things moving while at the same time being a good friend. It is a rare combination. Lastly, my students let me teach them and often teach me. They are a great gift in this best of professions.
—Sallye Mahan-Cox

Contents

Introduction

Design is the structure of a work of art. The elements of design—line, shape, value, color, space, and texture—are the parts or building blocks available to an artist. The principles of design—balance, unity, contrast, emphasis, pattern, movement, and rhythm—are a variety of possible effects that an artist can achieve by using or combining these building blocks. In every good design, the elements and principles work together. In looking at examples of artists' work, the constant question is "How have the elements been used to effectively apply the principles?"

Many of these reproductions may prompt discussion of more than one element of design. *Spurge, Withyham* by Charles Rennie Mackintosh, for example, is used to illustrate line, but the work might also prompt a discussion of color. Utilizing a reproduction several times will expand students' understanding of that individual work and stress the interrelatedness of the elements and principles of design.

Objectives and Assessment
Students should understand the objectives of each art assignment from the outset. Understanding creates better work and a more productive classroom environment. Determine the criteria before introducing the assignment. Use the assessment checklist provided with each reproduction as a starting point. Customize it to fit your needs. You may develop a rubric with standards or benchmarks.

Post, or have students copy, the objectives so that they know what is expected of them.

Review the objectives midway through an assignment. At the end of an assignment, use a grade sheet and have students self-assess in each of the criteria categories. Leave room for comments by both the student and the instructor. It is important that students feel comfortable with the assignment and not feel pressure to achieve one particular or perfect solution to any problem. Remind students that to master new things takes practice. Whenever necessary, demonstrate methods and procedures for students so they will be better able to create well-crafted work.

Brainstorming
To spur creativity, students should generate many ideas during the initial brainstorming step of a project. Some ideas will be good, some mediocre, and some not worth pursuing. Encourage all ideas so that students are not inhibited. Point out that professional designers work in this same way. Even the wildest notions should be included on a brainstorming list. The more ideas one has to select from the greater the possible outcomes of the project.

Using a Model

Make sure that students understand the important role of a model. The model must hold a pose and be serious about his or her contribution to the project. Models should not interact with the artists or vice versa. Both are partners who must focus on their own work. Remind students that they should work as efficiently as possible when working from a model so that the model's time is not wasted. Also explain to students that a model (or any subject for drawing or painting) should be ideally three to five times its height away from the artist to be seen as a complete subject.

Critiques

In class critiques, assign each student to another student's work. All students should take turns speaking. Have students use the assessment criteria so each critique is based on specific goals and objectives rather than on personal opinions. Discuss the importance of respect for the individual artist and the work. Feelings should not be hurt. Each student presenter should describe the best things about the work and advice for the artist on what might be improved. Help students practice good listening skills and good manners. Each artist should take notes on what is said about his or her work. Over time these notes will help students understand what things they do well and what areas they need to work on.

Additional Resources

Biographical and background information is provided with each reproduction. In the case of well-known artists, however, only a small facet of the artist's life and times can be represented here. See also the Bibliography on page 28. Books from the library and information from the Internet can provide additional information.

Spurge, Withyham
Charles Rennie Mackintosh

Introduction

In general, lines connect two points and are usually longer than they are wide. There are many different types. *Structural lines* hold a design together. *Outlines* generally refer to the outer edge of a silhouette. *Contour lines* describe the shape of an object and include interior detail. *Gesture lines* emphasize direction and fluidity.

One of the basic characteristics of a line is its direction. *Vertical lines* have height, stability, and dignity. *Horizontal lines* convey balance and calm. *Diagonal lines* can be active or express tension. *Curved lines* express movement that is fluid and sometimes continuous.

Another basic characteristic of a line is its quality. The *quality*, or weight, of a line can vary. A line may be thin or thick, jagged or fuzzy. An artist uses line direction and line quality to direct a viewer's eye across a composition and to convey certain feelings or moods.

Lines that are suggested but not actually drawn are called *implied lines*. These may occur when objects appear in a row, or when two objects or areas of color meet. An imaginary line from a figure's eyes to another figure or viewed object is a type of implied line called a *line of sight*. Implied lines also help to direct a viewer's eye across a composition.

Context

The Scottish artist Charles Rennie Mackintosh is primarily known as an architect and designer, but during his later career he also created textiles and paintings. His style is a combination of Arts and Crafts ideals and the continental Art Nouveau. His work, which includes *Hill House*, the *Willow Tea Rooms*, and the *Glasgow School of Art*, was greatly admired in continental Europe, especially in Vienna. Mackintosh was married to the artist Margaret Macdonald, with whom he often collaborated on designs.

Glasgow, Scotland, is located on the River Clyde. In the late nineteenth and early twentieth centuries, the city was an important shipbuilding and business center. Enormous luxury liners, similar to the *Titanic*, were built there. Many schools in Glasgow and in surrounding communities offered classes to train artists, designers, architects, and craftspeople. Mackintosh, who drew constantly, took advantage of these opportunities to further his education and improve his art.

Mackintosh was especially good at drawing flowers, and he studied them carefully. He was also familiar with architectural drawings, in which layers of tracing paper are used to separately show units such as heating, wiring, and windows. When the layers overlap, the whole building can be seen. In his contour drawings of flowers, Mackintosh allows the lines of one flower to show through others as if they, too, were drawn on separate layers of tracing paper.

Design Analysis

Charles Rennie Mackintosh completed the contour drawing *Spurge, Withyham* in 1909. He used pencil combined with watercolor washes. The drawing portrays the use of overlapping lines as described above, in which some flowers are visible through

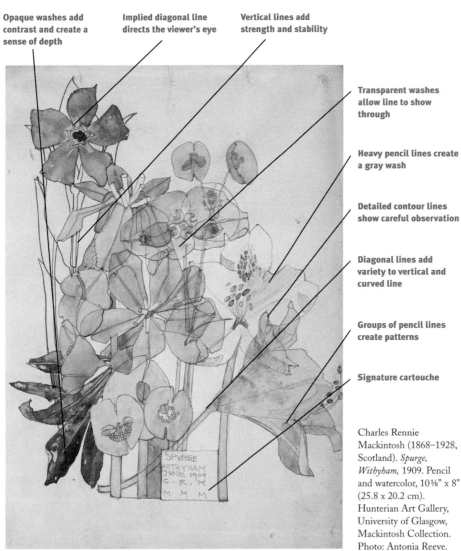

Opaque washes add contrast and create a sense of depth

Implied diagonal line directs the viewer's eye

Vertical lines add strength and stability

Transparent washes allow line to show through

Heavy pencil lines create a gray wash

Detailed contour lines show careful observation

Diagonal lines add variety to vertical and curved line

Groups of pencil lines create patterns

Signature cartouche

Charles Rennie Mackintosh (1868–1928, Scotland). *Spurge, Withyham*, 1909. Pencil and watercolor, 10⅛" x 8" (25.8 x 20.2 cm). Hunterian Art Gallery, University of Glasgow, Mackintosh Collection. Photo: Antonia Reeve.

others. This gives the overall design an abstract or puzzle-like feeling. It also provides the finished work with an interesting contrast. We can see the entire structure of each blossom, which gives them a sense of solidity. At the same time, we can see through the blossoms, which conveys a sense of transparency and evanescence.

To create this drawing, Mackintosh uses contour lines, which describe the shape and interior details of an object. The direction or movement of his lines vary. Some are vertical. Others are diagonal or curved. Because these various lines overlap, however, they connect the individual flowers into a single shape. Mackintosh directs the viewer's eye across the composition with the help of a strong implied line that runs from the upper left corner to the lower right one.

The quality of the lines varies. Some are lighter, others darker. Mackintosh usually began by lightly sketching the most important shapes of his subject and then drew over them with strong, heavier lines. Certain pencil lines in this drawing are so heavy and dark that they created a gray wash where they were touched by a wet brush. The overall detailed quality and exactness of the lines show that Mackintosh paid careful attention to his subject.

The lines of this drawing also convey a feeling of fluidity. Mackintosh seldom picked up his pencil while drawing and so his drawings create a sense of continuity and sureness. He also almost never erased, because erasing would break the flow of the lines and also might damage the surface of the paper.

The overlapping of lines and shapes in any design tends to flatten the space. To counteract this, Mackintosh added watercolor washes to his drawing. These transparent and opaque washes help to create a sense of depth and also provide visual interest. The two different kinds of washes also permit Mackintosh to cover up certain pencil lines and allow others to show through.

Notice that the title, date, and artist's signature are set off in a box, or cartouche, at the bottom of the composition. Such a device was common in both Japanese prints and in architectural drawings of the time. Mackintosh adopted this practice for all his work. He even experimented with type styles and designed one which today bears his name. Sometimes Mackintosh added the initials of a friend or his wife if they were present while he was working. The signature cartouche is carefully placed within the composition; it is never a mere addition or afterthought.

Teach

Share the biographical information about Charles Rennie Mackintosh with students. Point out that he was intensely interested in everything around him. He and his wife, Margaret, spent weekends traveling outside Glasgow, drawing everything from flowers and birds to old cottages and towering castles. These drawings became a visual library that he could turn to when creating new designs for buildings or textiles.

Share examples from books and magazines of buildings, stained glass, and other furnishings from the Arts and Crafts and Art Nouveau movements. Ask students to find similarities and differences in the two styles. Help them to identify aspects of both that may have influenced Mackintosh. Point out that Mackintosh also incorporated elements of local Scottish styles in his work.

Describe and discuss the variety of lines found in the drawing *Spurge, Withyham*. Have students identify as many types as possible. Also have students discuss the characteristics of these lines, including their movement or direction and their quality. Ask them what kind of feelings these lines create. Can students locate an implied line in the drawing? What function does this implied line have in the design? (An implied diagonal line from the upper left to the lower right directs a viewer's eye across the composition.)

Have students study the details of the drawing. Can they find places where Mackintosh seems to have picked up his pencil? Can they detect examples of both transparent and opaque watercolor washes? Why might Mackintosh have used one or the other? (The overlapping lines seen through the transparent center help to unify the design.) What flowers, if any, can they guess at or identify?

Activity

Description: Students will create a contour drawing that combines various line types and line qualities.

Materials

- Assorted flowers (other still-life arrangements may be substituted if necessary)
- pencils
- copy or typing paper
- watercolor paper or bristol
- watercolors
- brushes
- water containers
- paper towels
- drying space

Discuss: The lines of a good contour drawing describe both the shape and interior details of the subject. Remind students that varying the line types adds interest and that carefully chosen line direction and quality can help them convey a specific mood or feeling.

Procedure:

1 Create a still-life of different flowers in a simple vase or other container placed on a table or stand.

2 Students should sketch a few small studies to help them plan a basic composition. Remind them to think about ways to use line to direct a viewer's eye across the composition.

3 Have students practice drawing individual blossoms to develop expertise. Prompt them to vary the quality of the lines they use.

4 In pencil on watercolor paper, students lightly outline the major shapes of their planned composition. They should also indicate a location for their signature cartouche.

5 Students add contour lines to describe the individual flowers. They should let the lines of the flowers overlap each other. Remind students to draw slowly, observing the details of each petal and leaf. If students desire, they may attempt to leave the pencil on the paper as much as possible and do little or no erasing.

6 Students should add color to their drawings with light watercolor washes. Remind students not to cover up the contour lines. The color should add interest and depth to the design.

7 When the work is dry, students should add a signature and date to the cartouche.

Assessment Checklist

Does the drawing:
- show the overlapping of contour lines?
- include varied line types and line qualities?
- use line to direct a viewer's eye?
- include a well-placed cartouche?
- allow lines to show through the watercolor wash?
- use color to add interest and depth?

Above and Beyond

Students can create their own sketchbooks of contour drawings that depict local buildings, trees, and/or plants. They can then use the drawings as references for other art activities.

Correlations

Chapter 1, Lesson 1: Line Types, page 10

Édouard Manet Seated
Edgar Degas

Introduction

As described in the previous lesson, the two basic characteristics of a line are its direction and its quality. An artist uses line direction and line quality to direct a viewer's eye across a composition and to convey certain feelings or moods.

An artist can add further to the feeling or mood of a design by using line to create texture and pattern. Texture is the surface quality of an object—for example, rough or smooth. Pattern is the repetition of a surface element, such as stripes on a shirt. Through the use of different tools and media, an artist can greatly vary the textures and patterns created by line. The expressive qualities of watercolor lines, for example, may be quite different than those painted in oil.

An artist also may combining various types of line within a single composition. These mixtures can be used to create a sense of depth and to add interest, but they should be used sparingly. Line combinations are often most effective when they are carefully balanced with areas of visual rest.

Context

Edgar Degas is primarily known as a painter, but he also sculpted and made pastel drawings and prints. His early work was strongly influenced by the traditional, academic training he received at the Ecole des Beaux Arts in Paris. The academic artistic tradition valued painting over all other forms of artistic expression. Paintings were ranked in importance by their subject matter. Large paintings of historical or mythological subjects were considered the most important. Genre paintings of everyday scenes and still lifes were ranked lowest. An artist became a master by having work accepted for the official shows called *salons*.

Nineteenth-century Paris was a center of both the arts and intellectual activity. Writers, artists, and philosophers met in cafes to discuss and share the latest ideas. Throughout Europe, the industrial revolution and the expanding middle class had created economic and social pressures which led to the questioning of traditions and accepted theories. Everyday life increasingly interested Degas as a subject, and his paintings were continually rejected by the salons. At this time, he made friends with a group of young artists, later called Impressionists, who also favored everyday scenes and landscapes. The Impressionists valued the effects created by light and often painted out of doors, finishing their works in their studios. Also rejected by the salons, the Impressionists had sought alternative venues to show their work.

Edgar Degas and his friend the painter Édouard Manet (1832–83) shared an unusual relationship with the younger group of artists. Although friends with the Impressionists, neither Manet nor Degas exhibited with them. Degas also preferred to continue working primarily in a studio rather than outdoors. In a more traditional academic manner, he first made drawings and studies as the basis for his finished paintings. Eventually, works by Degas were accepted for exhibition at the official salons.

Although the two men sometimes disagreed, Manet often posed for Degas. Once, Degas gave his friend a painting of Manet and his wife in their living room. Manet did not like the way Degas had painted Madame Manet's face and decided to cut off that side of the painting! Degas was so furious that he

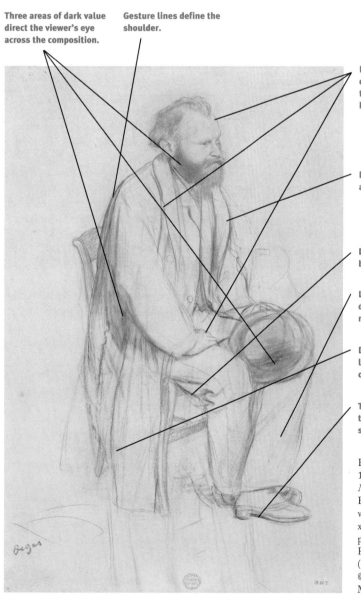

Three areas of dark value direct the viewer's eye across the composition.

Gesture lines define the shoulder.

Degas uses careful contour lines to define the profile, lapel, and hand.

Dark lines define form and create depth.

Dark sketch lines balance the hat.

Light lines so this area does not assume too much importance.

Degas uses swift gesture lines to describe the coat.

These lines help anchor the figure and create a sense of place.

Edgar Degas (1834–1917, France). *Édouard Manet Seated*, c. 1866–68. Black chalk on off-white wove paper, 13" x 9" (33.1 x 23 cm). The Metropolitan Museum of Art, Rogers Fund, 1918 (19.51.7). Photograph ©1994 The Metropolitan Museum of Art.

went to Manet's house and took back the gift. Later, however, the two became friends again.

Some Degas masterworks include the paintings *Dancing Examination*, 1874, and *The Orchestra at the Opera House*, c.1870; the sculpture *Little Fourteen-Year-Old Dancer*, 1879/81; and the print *Mary Cassatt at the Louvre*, 1885. In P. A. Lemoisne's book *Degas et son oeuvre*, Degas is quoted as saying "Drawing is not what one sees but what one can make others see." Sadly, by 1901 Degas was nearly blind. After this point he created mainly large pastel works and wax sculptures. Throughout his life, Degas collected the work of other artists and also kept some pieces of his own that he especially liked. This drawing of Manet was bought by the Metropolitan Museum of Art in New York after Degas died in 1917, at an auction of the artist's work.

Design Analysis

Édouard Manet Seated (c. 1866–68) is a study by Degas of his friend. In the drawing, Manet leans forward as he sits on a simple chair. He seems relaxed and willing to pose. He has even crossed his feet. We can tell it is winter because Manet is wearing an overcoat and heavy suit.

Degas chose to use a combination of lines to describe his sitter. The profile of Manet's face is drawn with careful contour lines. This slower line gave Degas the necessary accuracy and control for a detailed likeness of Manet. The right hand and overcoat lapel are also drawn using accurate contour lines.

Degas uses quicker gesture lines to describe Manet's shoulder and back. Swiftly sketched lines also travel around the figure. Degas repeatedly drew lines until he captured the shapes he desired, such as the drape of the fabric over the form. He even let the less accurate lines show alongside the others. Stopping to erase would have broken the rhythm and continuous energy of the drawing.

In some places, Degas drew heavy darker lines to give the composition a sense of depth and balance. The line at the bottom of the right sleeve, for example, helps to push Manet's arm forward as if his elbow is coming toward the viewer. The dark lines at the crease of the trousers help balance the weight of the dark hat. Degas also added light lines below the figure which may indicate a reflection on a polished wooden floor. These lines help provide an anchor for the figure so that it doesn't seem to float in the air.

In a few places, such as the shadow under the sleeve and on the hat, Degas used a stompe or stump to blend the lines creating a darker value. He used this technique, called *estompe*, in only a few places. These areas of darker value form a triangle that guides the viewer's eye from the face to the elbow and hat and back again. The lack of details at the hat and elbow make these areas less important and allow the viewer's focus to fall on Manet's face.

Teach

This drawing is one of many that Degas made of Manet. Some of the drawings were used as resources for paintings and prints. We know from people who watched him work that Degas drew quickly. His drawings combine characteristics of contour lines and gesture lines. Frequent practice helped Degas perfect his technique of using line combination.

Review the types of lines with students. Ask them to point out the places in which Degas used more controlled, accurate contour lines (the face, lapel, and hand) and areas where he used more fluid gesture lines (the shoulder and coat). What kind of feeling or mood is created by this combination of lines? Also have students compare the texture achieved by the lines in this drawing to the textures created by lines in other media.

Point out that there are lines in the drawing which Degas changed but did not erase. (For example, the faintly drawn coat bottom at the lower left.) Have students find other examples of multiple lines and suggest reasons why Degas did not erase them. (Possible responses: Stopping to erase would interrupt the flow; the lines add energy; the drawing is only a study, erasing might damage the paper.)

Have students look at Manet's posture and try to imitate it in the classroom. What feeling does this pose convey? (Relaxation; comfort; casualness) What might the pose say about the relationship between artist and subject and the atmosphere of the sitting? (Possible responses: They were good friends and comfortable with each other; Manet was patient and understood a fellow artist's need to draw.)

Have students locate three areas of value contrast. (Face, elbow, and hat) Explain that Degas used a tightly rolled, pointed cylinder of paper, called a stompe or stump, to blend these areas. How do these areas function in the drawing? (They help direct the viewer's eye.) Also have students identify the center of interest (the face) and describe how it is different from the other areas (more detailed, not smudged).

Activity

Description: Students will use vine charcoal, conté crayon, or graphite to create drawings of each other that use line combination.

Materials

- pencils, graphite sticks, conté crayon, or vine charcoal
- copy or typing paper for planning
- heavy drawing paper (70 or 80 lb)
- stumps (stompe) (may substitute tightly rolled paper towels held in place with tape)

Discuss: A comfortable artist/model relationship can contribute to the success of a drawing. Have students agree upon a pose that is both comfortable and characteristic of the sitter. Explain that to see the pose well, the artist should move away a distance equal to three to five times the height of the model. Before beginning, review contour and gesture lines and discuss the expressive qualities they can convey. Suggest that students not erase, but simply create new lines alongside or over the others.

Procedure

1 Have students practice drawing contour and gesture lines and using a stompe. They should create a few quick studies to help them agree on a pose for each.
2 Students should begin the sketch by making a few light marks to locate important parts of the composition (top of head, feet, shoulders, hands).
3 Students begin to draw the model. They should mix contour and gesture lines as necessary. Remind students not to erase.
4 Have students add a few lines to suggest an environment for the figure.
5 Students should add any desired details and use a stump to create a few areas of value contrast. These areas should both add depth to the drawing and help emphasize the center of interest.
6 The artist and sitter should exchange roles and repeat Steps 2–5.
7 After an informal critique, students should make any corrections or additions to their compositions. They should sign and date the finished work.

Assessment Checklist

Does the drawing:

- combine contour lines and gesture lines?
- convey a sense of the sitter through pose?
- use value contrast to provide a center of interest?
- include lines that hint at an environment or sense of place?
- sit well on the page?
- include areas of visual rest to help balance the composition?

Correlations

Chapter 1, Lesson 4, page 22

Goddess holding flowering branches
Teotihuacan IV

Introduction

As described in the introduction to the first large reproduction for this chapter, the surface quality of a shape may be light or heavy or it may be rough or smooth. These qualities help to define the shape or form and influence a viewer's response. Another important quality is whether a shape or form is static or dynamic. A static shape is one that stands still or appears to be at rest. A leaning or diagonal shape seems to be active, or dynamic. It conveys a sense of change or movement. This movement may be actual, as in a mobile, or implied, as in a drawing of a running horse.

Light also affects a viewer's perception of forms. Bright light can create dark shadows and brilliant highlights that emphasize the appearance of three dimensionality. Bright light may also help to define a form's texture. In diffused or soft light, forms tend to seem flatter and have less visible detail.

Context

A great pre-Columbian civilization called Teotihuacan flourished in what is now Mexico from about 200 BC to AD 800. This culture was centered around the city of Teotihuacan, which was abandoned in the second half of the eighth century after the destruction of its government and religious buildings. Today, archaeologists and art historians continue working to piece together clues about Teotihuacan and its people.

In central Mexico in a valley surrounded by volcanic mountains stand the remains of Teotihuacan. The city was an important trading center, and scholars believe that by AD 600 it was the sixth largest city in the world. The area was abandoned long before the Aztecs built their capital at nearby Tenochtitlan (present-day Mexico City) and Columbus set sail from Europe. Although the Aztecs recognized Teotihuacan as a sacred place of the gods and made pilgrimages there, they never settled within its ruins.

The city of Teotihuacan was built on a grid. Its main street, called "Avenue of the Dead," runs one and one-half miles long. Important temples and monumental pyramids were built along it. Two of the most impressive remaining structures are the Pyramid of the Moon and the Pyramid of the Sun, which sits over a cave. Many pre-Columbian cultures considered caves to be entryways to the underworld, holy places from which their gods and ancestors came. The placement of the city's pyramids and buildings line up with various astrological events at different times of the year, including solstices, equinoxes, and the rising and setting of stars and planets.

To house its large population, the city built structures similar to the apartment complexes of today. These structures were a new architectural development. A set of rooms encircled an interior patio, whose shaded walls were often painted with

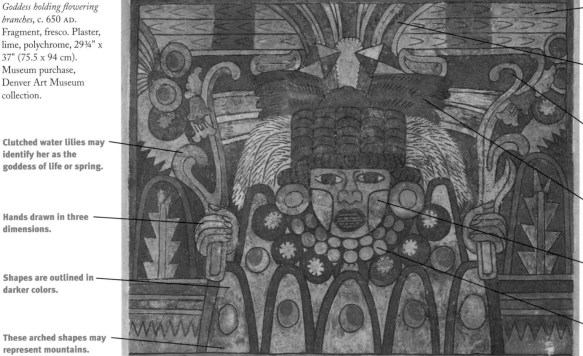

Teotihuacan IV, Mexico. *Goddess holding flowering branches*, c. 650 AD. Fragment, fresco. Plaster, lime, polychrome, 29¾" x 37" (75.5 x 94 cm). Museum purchase, Denver Art Museum collection.

Clutched water lilies may identify her as the goddess of life or spring.

Hands drawn in three dimensions.

Shapes are outlined in darker colors.

These arched shapes may represent mountains.

Textured bands may represent a serpent.

Note the close range of values among the colors.

Dynamic curving shapes add movement and energy.

Feathers were important items of trade.

The shapes of the face and objects are flat.

Curved rows of circles help set off the figure's face.

colorful murals. The paint used to create the murals contained small bits of mica, which reflected the sunlight and made the murals appear to glow. These murals, which are drawn and painted in flat shapes, contain scenes of religious rituals. A storm god, a goddess, a tree of life, and a feathered serpent—all believed to be important figures in the Teotihuacan religion—are common subjects.

Design Analysis

The mural *Goddess holding flowering branches* was probably painted during Teotihuacan's Metepec period (350–750 AD). Its provenance, or history of ownership, is only known back to the 1950s. Museum curators, archaeologists, and art historians have had to study the mural very carefully to authenticate and date it. They conduct their detective work by comparing a piece to other artworks about which more is known.

This fragment was painted directly on a wall as a fresco, not painted and then mounted. It measures 31" x 41" (79 x 104 cm) so that the goddess appears almost equal in size to a human. Unlike many other murals of the time, this fragment has been restored or repainted. The prominent colors are red, blue, green, and yellow, but because they are close in value, with no use of black or white, it takes time to decipher the details.

Most of the shapes that make up this fragment are organic and dynamic. The curved groupings of small circles, the arches along the bottom, and the goddess's headdress and clutched branches give the mural a sense of energy and movement. The symmetry of the piece and certain static geometric shapes in the background provide a contrasting sense of permanence and stability. Almost all the shapes are flat and enclosed by darker outlines. One exception is the goddess's hands which provide a sense of three-dimensional space. Throughout, very few of the shapes have interior textural markings.

Although there is no certainty to the mural's interpretation, the horizontal bands along the top may represent a serpent that ran along the top of the composition. The flowering branches appear to be water lilies, which may be attributes of the goddess and may symbolize spring or life. The headdress seems to be decorated with feathers, which are known to have been important objects of trade at Teotihuacan. Her large necklace may also be symbolic. The arched shapes at the bottom may represent mountains from which the goddess rises like the plumes of smoke from the volcanoes surrounding Teotihuacan.

Teach

Point out to students the great variety of shapes found in this mural fragment. Ask them to identify those that are geometric and those that are organic. Have students describe the mood or feeling that this mixture of shapes creates. Would students describe the overall result as static or dynamic? What elements contribute to the two qualities? Help students perceive the overall flatness of the outlined shapes and the lack of much textural detail.

Ask volunteers to identify the various objects worn by or surrounding the goddess. What might some of these objects represent? Share with students some of the ideas that scholars have developed to help them interpret the mural. Point out that some of the shapes and details may be difficult to distinguish because the artists did not mix black or white pigments with their colors. Therefore the values are very close. Explain that this particular fragment has been restored or repainted to make the colors and shapes more distinct.

Ask students to imagine what the areas surrounding this fragment might have been like. Also, help them to appreciate the fact that such murals were common decorations in the courtyards of the apartment complexes surrounding Teotihuacan. What would have been involved in creating such works? In what ways are these murals similar to the types of decoration common today in homes and public places? Explain that such surviving pieces of art are powerful clues that help us better understand civilizations that left behind no decipherable written records. The culture of Teotihuacan was even a mystery to the Aztecs 600 years before the arrival of the Spanish conquistadores.

Activity

Description: Students will create a painted mural or panel painting using organic and/or geometric shapes. The subject may be a historical event, a class portrait, or other suitable subject.

Materials

Pencils, paper, paints, brushes, rulers, and any necessary references. Other materials such as masking tape, graphite sticks, and yardsticks may depend upon whether students create individual panel paintings or a group wall mural.

Discuss: Brainstorm with students to come up with ideas for possible subjects. Remind students of the relationship between positive and negative shapes and the feelings that are conveyed by organic, geometric, static, and dynamic shapes.

Procedure

1 Have students select a subject for their mural.
2 Students should create a few quick compositional studies. They should enlarge the best one to use as a guide.
3 Have students refine the shapes that make up their mural and add details. They may decide to add outlines to the shapes and use little interior textural details as on the Teotihuacan mural.
4 Have students decide on a color scheme for the mural. Will they use black and white to vary the values or not? They should add color notations to the mural plan. Point out that color choices can influence the relationship between positive and negative shapes.
5 Depending on the surface to be used, students should transfer their design to a panel, wall, or other flat surface. They may use a grid to help them.
6 Recommend that they paint the large shapes first, then the smaller ones. Leave any outlines and textural details until last.

Assessment Checklist

Does the design
- include a variety of shapes?
- use positive and negative shapes to create visual interest?

Does the mural
- follow the design?
- display neat craftsmanship?
- use color to enhance the intended feeling or mood of the shapes?

Above and Beyond

Have students research the art and culture of the later Aztec civilization that flourished near the site of Teotihuacan. What kinds of buildings and cities did the Aztecs construct? What figures were important in their religious practices? How do these Aztec cultural achievements compare to what we know about the Teotihuacans? If possible, have students find reproductions of Aztec codices and compare the shapes and designs of these drawings to the *Goddess holding flowering branches* mural.

Correlations

Chapter 2, Lesson 9, page 46

Aube et Crépuscule (Dawn and Dusk)
Emile Gallé

Introduction

When a line crosses itself or intersects another line to enclose a space, it creates a shape. Shapes have two dimensions: height and width. Forms are three dimensional because they also have depth.

There are two basic categories of shapes and forms. Geometric shapes and forms are regular and precise. Triangles and circles are geometric shapes, and a cube is a geometric form. Organic shapes and forms reflect living things. They are often curved and irregular. The outline of a maple leaf is an example of an organic shape, and a pear is an organic form.

Every design is made up of both positive and negative shapes. Positive shapes usually represent the tangible or solid aspects, and negative shapes are the areas that surround them. In a landscape, for example, the trees are positive shapes. The background and sky are negative ones. In a sculpture, the negative shapes are the empty spaces around the form. A strong composition carefully balances both positive and negative shapes.

Shapes and forms also have different qualities or appearances. Some may be light or heavy. Others may have surfaces that are smooth or textured. By emphasizing surface qualities, artists can create shapes and forms that are lifelike and that have visual interest.

Context

Art Nouveau was the "new art" style of the 1890s and turn of the century. This popular style influenced the design of everything from furniture and books to wallpaper and architecture. The hallmark of the style was curving and flowing organic shapes and forms. The popular subjects reflected the nineteenth-century interest in nature, which ranged from exotic botanical drawings to the collecting of seashells and insects.

French designer Emile Gallé is best known for his masterful Art Nouveau works in glass. While studying in Italy and Germany, Gallé visited famous gardens, where he saw many rare and fascinating blooms. He was intrigued by their colors as well as by their forms. Upon returning to France, Emile joined the family glass business. In the evenings, he took walks that allowed him to continue studying and drawing nature. His observations and constant experimentation led him to create fabulous vases, goblets, and lamps.

Eventually Gallé took over the family factory and hired the best glass workers and master craftsmen. He believed that a good working environment increased productivity; the work areas were spacious and well lit and the grounds were landscaped with trees and flowers. Above his studio door he placed the words: "Our roots are in the depth of the wood—on the banks of streams, among the mosses." He even collected an extensive library for the workers' use. The business became a great success.

Emile Gallé (1846–1904, France). *Aube et Crépuscule (Dawn and Dusk)*, 1904. Rosewood, ebony, mother of pearl, glass, 4.7' x 6.3' x 7.6' (1.43 x 1.92 x 2.18 m). Musée de l'Ecole de Nancy, from the collection of Henry Hirsch.

Dusk headboard.

Gold dust sprinkled by the moth.

Marquetry relief shapes made of several woods.

Marquetry landscape.

A plain bedcover sets off the decorative bed.

Opal glass drop engraved with moths.

One of few straight lines.

Curving mother of pearl bands add sparkle and visual interest.

Ink cap mushroom lamp.

Interesting negative shapes.

Frames outline the curved shapes and add structural stability.

Dawn footboard.

Base represents the forest floor.

In 1885 Gallé went to a specialty carpenter's shop to have a display table made for his glassware. He was so intrigued with the rare woods that he built a factory to produce fine furniture. The technique of marquetry (using inlaid shapes of different colored woods) allowed his decorative designs to be transferred to wooden surfaces. Structural elements were also carved into natural forms such as stems and branches. During these years, Gallé designed some of his most famous pieces, including the *Orpheus and Eurydice* cameo glass vase (1888–89), the *Les Coprins* mushroom lamp (1902); and the *Aube et Crépuscule ("Dawn and Dusk")* bed (1904).

Design Analysis

Emile Gallé designed the *Aube et Crépuscule* bed in 1904 for his friend and patron, Henri Hirsch, who was getting married. Because the piece is functional, its basic structure is less experimental. After all, people had to be able to sleep in it! But, wherever possible, Gallé added curving and flowing shapes. The structural design of the headboard, footboard, and legs contains almost no straight lines, and the surface decoration emphasizes these organic shapes.

For his design theme, Gallé chose the moth, a creature—like sleep—that comes with the darkness and vanishes with the light. The headboard represents dusk and the footboard dawn. Both are decorated with marquetry shapes in relief. Gallé selected a variety of woods for their distinct colors and grains and added sparkling mother-of-pearl mosaic bands to the curving shape of the moth's wings. On the headboard the evening moth swoops down over the marquetry landscape to scatter gold dust (dreams perhaps?) and bring the night. The landscape itself is created by inlaid shapes cut from different woods; it is not painted. On the footboard the jaws of the dawn moth hold an opal glass drop, perhaps to symbolize the coming light of day.

Beside the bed is a lamp, *Les Coprins (Ink Caps)*, designed by Gallé in 1902, two years before the bed. It captures the changing shapes of a mushroom at various stages of its growth. Notice the interplay of positive and negative shapes, which change and seem to almost move as you view the lamp from different sides. Although this piece is also functional, Gallé was able to be experimental with its basic structure. And the mushroom caps themselves are ideal shapes to house the lighting fixtures. Oddly enough, the ink cap mushroom that inspired the design is poisonous! Perhaps Gallé intended a reference to the nightmares that are sometimes found in sleep and within the darkness of a forest.

Teach

Have students evaluate items at home and in class for their properties. Are they shapes or forms? Are they geometric or organic? Ask students to identify the positive and negative shapes that make up these items and describe the relationship between them. Then ask students to identify and describe the shapes and forms of Gallé's bed. Point out that organic shapes can be found in the structure of the bed (headboard, footboard, and legs) as well as in the surface decoration. What elements can students find that were inspired by nature? (landscape, moths, materials of wood and mother of pearl) Ask students why Gallé might have chosen the motif of a moth for his design and share possible interpretations with them.

Have students identify and describe the positive and negative shapes of the bed. What kind of feeling do these shapes create? You may also add a discussion of the bedside lamp. How do these imaginative designs differ from a standard bed and table lamp? Have students search for the few straight lines visible in Gallé's design. Why do they think all the lines aren't curved? (Possible answers: Structural necessity, to accommodate the mattress, to add some contrast to the organic shapes.)

Explain that furniture design was a second, almost accidental, career for Gallé. Point out that he began as a glass designer and that his explorations of curving and flowing glass shapes and his interest in nature greatly influenced the furniture he produced. He believed that organic shapes and forms could and should dictate the design of furniture and decorative objects. Have students look carefully at the details of the bed's surface. Help them to understand that the bed is not painted but inlaid with pieces of different color woods, a technique called marquetry.

Activity

Description: Students will design and create a scale model for an original bed. Shapes and forms from nature, architecture, or even literature may be used as inspiration for their designs.

Materials:
• paper and pencils
• foam core
• chipboard
optional:
• papier-maché, clay, wood, found objects
• glue, nails, and wire
• gesso, paint, brushes, and/or fabric for decoration

Discuss: Encourage students to consider many designs. Have them especially think about the interplay between positive and negative shapes. To create scale models, students may use a ratio of two inches to one foot. A twin bed is 39" x 78"; a double 54" x 78"; a queen 60" x 80"; a king 76" x 80".

Procedure:
1 Each student should brainstorm and sketch at least three ideas for a bed design. Once a design and theme are selected, students should sketch ideas for shapes and images that might decorate the bed's surface.
2 As a class, critique these designs and have students make adjustments. Are the positive and negative shapes interesting? How does the surface decoration relate to the structural design? How well with a student's chosen material work to create a structurally sound model?
3 Students measure and cut out the headboard, footboard, and side pieces.
4 Students assemble and decorate their beds. They should consider whether to assemble the bed before or after painting and decorating.
5 Review finished designs. If desired, students may add a mini-mattress and bedclothes to set off their finished models.

Assessment Checklist
Is each design:
• drawn to scale?
• interesting and original?
• reflective of inventive positive and negative shapes?
Is each model:
• sturdily and neatly built?
• decorated using shapes and forms that complement the bed's structure?

Above and Beyond
Since the Industrial Revolution, a discussion has been ongoing about the importance of the workplace environment. Ask students to write down and then discuss their ideas about whether or not a stimulating and/or physically attractive environment is beneficial to a workplace. What are the positive and negative points to each side of the argument? What makes your school a rich, stimulating environment for learning? How might schools and/or standard offices be improved?

Correlations
Chapter 2, Lesson 1, p. 36

3.1 Value

Spring
Peter Bruegel The Elder

Introduction

Value is the range of light to dark. It includes the lightness or darkness of both grays and colors. Value is created by light or its absence. Areas facing a light source are lightest in value. Those facing away are darker.

Value can convey an impression of space or depth in a two-dimensional design. In a landscape or cityscape, for example, the areas in the distance are usually lighter than those in the fore-ground. A range of value, such as is used in shading, can also give a sense of roundness or volume to an individual object.

Artists also use value for its expressive properties. Light values can depict happiness or warmth. Designs that have bright lighting, also often have dark and clearly defined shadows. Dark values may be used to depict cold, mystery, or sadness. Designs without a bright light source and shadows tend to appear flatter.

Context

The painter Pieter Bruegel (c. 1525–1569) was born in what is now The Netherlands. After his artistic apprenticeship, he spent four years in Italy studying the Renaissance masters. Bruegel's favorite subjects were the everyday events of peasants' lives and seasonal activities. Sometimes he and an artist friend would even disguise themselves as peasants and go out into the countryside to observe and take part in rural life.

In the Netherlands of the sixteenth century, there was widespread political and religious upheaval. The rulers of a divided Holy Roman Empire fought with one another, and the spreading Protestant movement contested the traditional Catholic dominance. Many artists, authors, and philosophers were careful about how they stated their opinions. They were afraid that if a leader came to power who disagreed with them they would be persecuted or even killed. Ideas were often couched in symbolism; the viewer or reader interpreted the work himself and the artist or author could deny it. Today we may see Bruegel's works as simple depictions of everyday life or as commentaries on the exploitation of the poor by the rich. In either case, Bruegel saw man's fate as a part of the natural order. A peasant's life was dictated by work and the changes of season, with occasional breaks in the routine for weddings and festivals.

Bruegel's art was unappreciated for centuries after his death. His subjects were thought crude and primitive. Today Bruegel's best works, including the paintings *The Return of the Hunters* (1565) and *Peasant Wedding* (1566), are considered masterpieces of art.

Design Analysis

Spring is an ink drawing by Pieter Bruegel. It was probably part of a set of drawings of the seasons which would have been engraved and then printed. The growth of

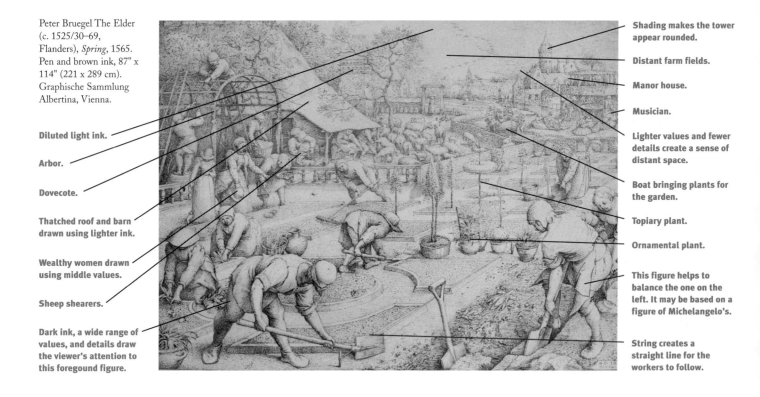

Peter Bruegel The Elder (c. 1525/30–69, Flanders), *Spring*, 1565. Pen and brown ink, 87" x 114" (221 x 289 cm). Graphische Sammlung Albertina, Vienna.

Diluted light ink.

Arbor.

Dovecote.

Thatched roof and barn drawn using lighter ink.

Wealthy women drawn using middle values.

Sheep shearers.

Dark ink, a wide range of values, and details draw the viewer's attention to this foregound figure.

Shading makes the tower appear rounded.

Distant farm fields.

Manor house.

Musician.

Lighter values and fewer details create a sense of distant space.

Boat bringing plants for the garden.

Topiary plant.

Ornamental plant.

This figure helps to balance the one on the left. It may be based on a figure of Michelangelo's.

String creates a straight line for the workers to follow.

the Dutch middle class during the Renaissance created a busy market for such prints, which were less expensive and more readily available than large oil paintings.

Bruegel often drew in chalk on location and would later refine the drawings in ink in his studio. Sometimes these drawings would also be used as references for oil paintings. In *Spring* Bruegel has used the common Renaissance technique of diluting his ink to obtain light, medium, and dark values. He also makes use of aerial perspective, depicting things that are closer in darker values and with greater detail than those in the distance.

The subject is a wealthy landowner's country estate in the spring. In the immediate foreground, peasants are converting a field to a formal garden in the popular Renaissance style. This area is drawn using the greatest range of values and the most details. Notice especially the dark inks that create the volume and solidity of the peasant digging in the left foreground.

Behind this figure is a well-dressed woman who oversees the work. By her side is a fashionably dressed younger woman wearing an elaborate ruff or collar. These figures are reduced in size and drawn using middle values. Behind them, peasants have built an arched arbor and are draping and tying grapevines over it. In the summer, these vines will create a place of cool and shade for the owners.

Drawn in lighter value at the rear stands a barn with a thatched roof. Under the side shed, peasants are shearing sheep; wool was a valuable commodity in the Dutch economy of the time. Above this shed is the tall tower of a dovecote where doves and pigeons nested.

At the right of the composition is a boat laden with plants for the new garden coming up a canal or stream. Wealthy couples, perhaps guests of the owners, lounge on the grass entertained by musicians. There is a table laden with food. In the background stands a complex manor house, whose tower is given volume and roundness through the use of shading. In the distance, a pale flight of geese leads the viewer's eye over faraway farm fields which are drawn in very light ink and with few details.

In this work, Bruegel is clearly drawing a distinction between the activities of the wealthy and those of the peasants. What might we make of the fact that the largest figures are both workers? Perhaps Bruegel is reminding us that without the peasants none of this would be possible. It is also interesting to note that the plants used to create

this garden are ornamentals; they are not vegetable or food plants. Only the wealthy could have used so much land and money for purposes other than the immediate needs of food and shelter.

Teach

Before discussing the work with the class, have students write a description of the drawing. They should note as many things as they can, including activities, animals, buildings, and implements. Pair students to share their lists and learn from each other. Then make a class list. How does the artist organize all these things? Which are in the foreground, the middle ground, and the background? Make sure students realize that the drawing depicts peasants creating an ornamental garden for wealthy landowners.

Ask students to compare the values and details used in the foreground with those in the middleground and background. Point out that the closer figures are drawn using a greater range of values, the darkest ink, and more details than those farther away. Explain that this effect is known as aerial perspective since water vapor in the atmosphere makes distant details, values, and colors lighter and less distinct. Have volunteers count the different values of ink used in the drawing. Also have students identify areas in which shading helps create the appearance of volume or fullness.

Explain that this drawing is one of many that Bruegel made of peasants going about their daily hard work. Help students understand that it was a radical idea in sixteenth-century Europe that the lives of simple people was a worthy subject for art. The fashionable subjects set by the Italian Renaissance were gods and goddesses, mythological settings, and portraits of nobility and generals. Ask student for their opinions about what Bruegel might have been saying about the relationship between the wealthy and the peasants.

Activity

Description: Students will create a drawing of an everyday scene using pen and ink. The drawing should include at least three different values to create a sense of depth.

Materials

Pencils, pens, ink, droppers or dropper bottles, palettes or tiny cups to dilute ink, plate finish bristol or other ink drawing paper not larger than 11" x 14". (Pen and ink technique is hard to sustain on a large scale and can be very time consuming.)

Discuss: References enable an artist to reach beyond memory. Suggest that students use or take photos of their chosen subject. Discuss how a range of values can create a sense of space in a drawing. Also review the use of shading and foreground details. Brainstorm ideas for topics. (See brainstorming in the Introduction.)

Procedure

1 Once students have chosen their subject, they should sketch several compositional ideas on scrap paper. Make sure each composition is suitable for depicting depth.
2 Students may use pencil or very light ink to map out the major shapes of their composition on good paper.
3 Have students begin inking their drawing. Remind them to use darker values and greater detail in the foreground. Make sure students dilute the ink to achieve a range of values. Suggest areas in which they may use shading to give the appearance of volume.
4 While inking the drawing, students should periodically pin it up and step away to check it. Are they creating a distinct foreground, middleground, and background? They may make adjustments as necessary.

Assessment Checklist

Does the drawing have
- a range of values created by diluting the ink?
- a sense of depth?
- areas of volume or roundness created by shading?
- areas of darker value and greater detail in the foreground?
- good craftsmanship, such as a balanced composition and no smears or blobs of ink?

Above and Beyond

Discuss with students how value can also help to direct a viewer's eye through a composition. Have volunteers suggest ways in which Bruegel uses value in *Spring* to achieve this. Then have students study their own works to evaluate such compositional movement. How might they use value more effectively in future designs?

Correlations

Chapter 3, Lesson 3, p. 60; Chapter 3, Lesson 4, p. 64

Last Red Tulips (Baltimore Spring 84)
Carolyn Brady

Introduction

As already outlined, value is the range of light to dark. It applies to both grays and colors. An artwork that has many light-valued colors is said to be high-keyed. High-key colors have been mixed with white. They are also called pastel colors. An artwork that has many dark-valued colors is said to be low-keyed. Low-key colors have been mixed with black or gray.

When light-valued colors are placed next to dark-valued colors this creates value contrast. This contrast may help a viewer distinguish between the different parts of a design. An artist also may use value contrast to call attention to one part of a design or to create a center of interest.

Context

Carolyn Brady grew up and went to college in Oklahoma, where she studied painting. Her early works include large, appliquéd fabric pieces. She did studies for these works in watercolor. Watercolor itself became increasingly interesting to Brady, and eventually she stopped working with fabric and just painted. Flowers are the subject of many of her watercolors.

Photo Realism is a style in which an artist attempts to render a factual representation of his or her subject. Many Photo Realists use a camera to begin the design process. Then they may edit or crop the photograph or combine several to create a single composition. Brady uses a camera to capture perfectly composed images as the starting point for her paintings. Her finished works are large; some of them measure five by six feet. Brady says "I am interested in the idea of a painting so big you want to walk around in it." Her choice to work in such detail on a large scale in watercolor requires great technical skill and focus.

Design Analysis

Last Red Tulips (Baltimore Spring 1984) is a large (38" x 55") watercolor painting. It is based on a photograph that Carolyn Brady took in her garden. She begins by projecting the color negative onto watercolor paper. After lightly outlining the shapes in pencil, she adds color.

This painting, which is one of a series of three, dramatically combines areas of bright light and dark shadow. This contrast of values perfectly captures the effect of intense midday sunshine. The shapes of each petal and leaf are very precise, like objects in a crisply focused photograph. The low-key color of the leaves, which appear bleached from the sunlight, contrast with the high-key color of the red tulips. The two tulips at the center seem to project outward almost into the viewer's face. The dark values at the left and lower right also help to focus the viewer's attention on the center of the composition.

Notice that the sharp focus of the foreground tulips fades and becomes somewhat blurry as the eye moves back into the picture. This is a common effect in close-up photography, which helps Brady to create a sense of depth in the painting. Since the

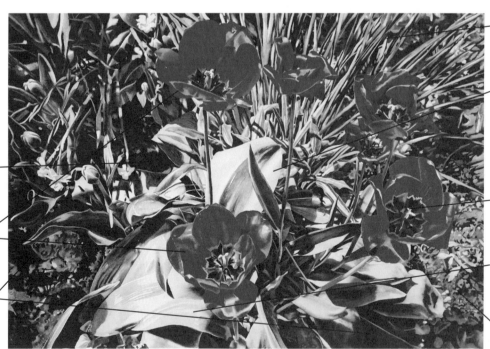

Carolyn Brady (b. 1937, US). *Last Red Tulips (Baltimore Spring 84)*, 1984. Watercolor over graphite on white wove paper, 38" x 55" (96 x 140 cm). Worcester Art Museum, Worcester, Massachusetts, National Endowment for the Arts Museum Purchase Plan.

Shadows create depth and hint at mysterious places unknown to the viewer.

Sharp focus pushes the tulips into the foreground.

Dark values at the left and lower right help focus attention on the center of the composition.

Blurred focus helps create a sense of background depth.

The low-key color of the leaves depicts the bleaching effect of the intense sunlight and contrasts with the high-key color of the tulips.

Dark values help the center of the tulips to recede.

Brushstrokes remain visible.

The range of values accentuates the texture of the dirt.

work combines a wide range of values and a great deal of detail, the composition would be flat and difficult to read without this contrast of focus. The fact that the closest shapes also overlap everything else helps project them forward and draw the viewer's attention.

Most Photo Realist painters do not want their brushstrokes to show or the painting's surface to have texture. By creating a smooth and flat surface, they enhance the photographic quality of their work. Brady, however, is becoming more interested in the abstract nature of her compositions, and she often makes marks that remain visible in the final work. The fact that her subjects appear several times larger than life and are viewed from above adds to this sense of abstraction. When seen from a distance, Brady's paintings are recognizable as common flowers and gardens. When viewed up close, they dissolve into abstract shapes and areas of value and color.

Teach

Point out that Carolyn Brady's watercolors are executed in a style known as Photo Realism. Ask students what about the painting reminds them of a photograph. Explain that Brady works from a photograph rather than from life, because even over the course of a few minutes great changes can occur in light and value. Can students guess the time of day when the original photograph was taken? (probably midday on a bright day)

Also, by projecting the negative onto her working surface, Brady can perfectly replicate the details captured on film. Discuss with students the idea of working from a photograph that you have taken as opposed to simply copying someone else's. Point out that Brady also uses her camera as a viewfinder that helps her to locate the perfect compositions for her paintings.

Explain to students that for an artist to use the medium of watercolor to create such large and detailed works is uncommon. Help them see that Brady manipulates the medium to achieve an exactness of value, shape, and color that is usually associated with photography. This is technically quite difficult because watercolor is difficult to control, especially over such a large area.

Help students perceive the wide range of values visible in this painting. Ask them to identify areas of light, medium, and dark values. How does Brady contrast these values to create visual interest and a center of attention? (The shadows and areas of dark value at the left and lower right draw the

viewer's attention to the center.) Also have volunteers locate and describe the use of low-key and high-key colors. How does this range of color create a sense of depth in the painting? (The high-key red of the tulips makes them pop forward.) What other aspect of the painting helps to provide a sense of depth? (The foreground tulips are in sharp focus and overlap everything else; the background is somewhat blurry.)

Activity

Description: Students will create a large painting from their own photograph of a still-life they have set up.

Materials

- still-life objects
- controlled lighting source
- pencils
- paper
- paints
- brushes
- camera and color film
- projector or clear acetate and permanent markers (to make grid overlays to enlarge photos)

Discuss: Demonstrate how to use your particular camera. Brady uses a 35 mm manual camera with a 55 mm lens. This gives her a very shallow depth of field. A disposable camera may also be used. (Have a plan for getting the film processed and printed as soon as possible.) Discuss with students that their set-ups should offer a combination of light and dark values.

Procedure

1 Have students set up their still-lifes so that they work from a variety of vantage points. Students also should experiment with lighting to achieve as wide a range of values as possible. Remind them that dark shadows can work well to achieve value contrast.
2 Suggest that students use viewfinders or small mats to explore possible compositions. Once they settle upon the two or three best choices, have them photograph their choices. If possible, use high speed film rather than a flash, which might greatly alter the lighting effects of the still-life.
3 Have students enlarge and transfer the best negative to paper using a projector or an acetate grid overlay. They should lightly draw the major outlines of the composition. They may adjust or crop the set-up if necessary to achieve a more effective composition.
4 If using watercolors, students should use the white of the paper for the lightest val-

ues. They also may use masking fluid to block them out. Recommend that students begin working on the large light value areas. They can then add medium values, and finally darker values and details. Remind students to periodically step back from their paintings to review the range of values and sense of depth. They may make adjustments as necessary.

Assessment Checklist

Does the photograph
- include a range of values?
- have a strong light source?
- capture an interesting composition?

Does the painting
- include a range of values?
- combine high-key and low-key colors?
- have a center of interest?
- display good craftsmanship, such as colors that are not muddy and objects that are accurately rendered?

Above and Beyond

Have students paint two versions of the same landscape or cityscape at two times of day when the lighting is quite different. For example, at midday and at sunset. Have them compare the range of values in each and discuss how the altered light affects the high-key and/or low-key colors? Also have them notice what happens to the details of the scene as the light changes.

Correlations

Chapter 3, Lesson 3, p. 60; Chapter 3, Lesson 4, p. 64

Introduction

Colors have three properties: hue, value, and intensity. Hue is the name of the color itself; it refers to the color's position in the spectrum. Yellow, red, and blue are the primary colors or hues. From them the secondary hues orange, violet, and green are mixed. If hues are arranged on a color wheel, complementary colors are those directly across from each other.

Value is the range of a color's lightness and darkness. A hue to which white has been added is called a tint. Adding gray to a hue produces a tone. Adding black produces a shade.

Intensity is the quality of light in a hue. Brighter colors are more intense; duller ones are less intense. An artist can lessen the intensity of a hue by adding a neutral: white, black, or gray.

Context

Winslow Homer was born in Boston, Massachusetts. Trained as a commercial artist, he first worked as an illustrator. In the mid-nineteenth century photography was new and not yet used in newspapers and magazines, so illustrators were in great demand. Homer was talented, and *Harper's Weekly* hired him to write about and illustrate the Civil War.

After the war, Homer studied painting in Paris. He became interested in depicting scenes of water and everyday life, and throughout his life he would continue to travel for study and work. During frequent trips to the Adirondacks, Homer sometimes painted as many as thirty watercolors in two weeks. As he came to know the area, he chose not to portray the well-to-do guests of the resorts but focused instead on the local residents and guides who spent their whole lives in the mountains.

In the 1880s, Homer built a studio in Prout's Neck, Maine, which became his full-time home. He painted many dramatic oils of the ocean and even stayed there in the bitter winters when the summer residents had left. In 1884, a magazine hired Homer to illustrate an article on the Bahamas. This was a chance to paint color and light that were quite different from those of the New England coast. He spent two months in the islands and created a masterful series of bright and airy watercolors.

During the last ten years of his life, Homer continued to paint in oils, but was not as active outdoors. He died in his studio in 1910. His best-known works include *Snap the Whip*, 1872; *The Fog Warning*, 1885; *The Fox Hunt*, 1893; and *The Gulf Stream*, 1899. After Homer's death, fellow painter Kenyon Cox wrote about "the accuracy of his observation, the rapidity of his execution and the perfection of his techni[que]."

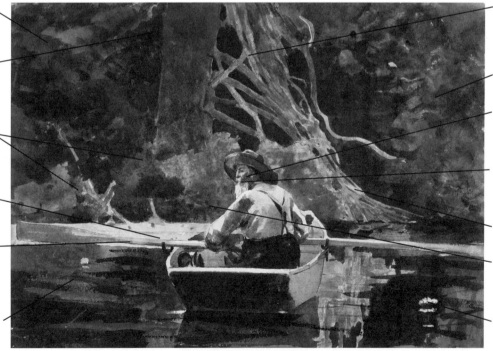

Wet colors allowed to mix to capture the shadowy background.

Dark value blue contrasts with lighter values.

Bright primary colors contrast with dull colors and neutrals.

Paint blotted out to reveal lighter values.

Horizontal line of the oars balance the large vertical of the background tree.

Drier brushstrokes allow the texture of the paper to be visible.

Dull yellow helps break up the background without calling attention to itself.

Wet paint.

Bright red adds life and interest to the face.

The figure's face is located at the exact center.

Light value blue.

Neutrals are mixes of primary colors, not made with black.

A few highlights reveal the white of the paper.

Winslow Homer (1836–1910, US).
The Adirondack Guide, 1894.
Watercolor over graphite on paper, 15⅛" x 21½" (38.4 x 54.6 cm).
Museum of Fine Arts, Boston, Bequest of Mrs. Alma H. Wadleigh.

Design Analysis

Winslow Homer first visited upstate New York in 1870, and he returned many times. Homer had been taught to use watercolor to enhance his illustrations, but he decided that he wanted to master its expressive qualities. Homer practiced diligently and created a huge portfolio of paintings as he explored the possibilities of the medium.

During Homer's lifetime, the Boston Museum of Fine Arts acquired a large collection of Japanese paintings and prints. We do not know what specific works Homer may have seen and admired, but his sense of composition, his fluid use of wet paint, the areas of flat color, and the stripping away of extraneous details all seem to reflect a Japanese influence.

Homer painted *The Adirondack Guide* in 1894. Many of his watercolors were large for the time, and this work measures 15" x 21". The man in the picture is probably Orson Phelps, a well-known mountain guide. He is alone in his rowboat and has stopped to listen to or look at something. Perhaps a deer has come down to drink or a bear is moving along the riverbank.

Homer's use of color is rich and fluid. The neutrals are made from mixing primary colors rather than by using black. The background has been freely washed in and while still wet the artist added other colors, letting them flow together. This technique is well suited to capturing the indistinct shapes of the shadowy trees and underbrush. The blurry background also emphasizes the importance of the more crisply outlined figure and boat.

The guide's face is in sharpest focus. Touches of red and blue make the face lively and interesting. These bright colors are set off further by the darker, duller color of the hat. Although Homer placed the face at the exact center of his composition, the design is not static. The horizontal line of the yellow oars, which echoes the shoreline, adds visual interest and balances the verticality of the huge tree in the distance. The light green bushes between guide and tree help to frame the figure and to push the tree back in space. Also, the bright red shapes at left contrast with and help to balance the complementary green color.

Homer wrote on the back of this painting "Picture for a dark corner" before he sent it to his art dealer. It was sold in six weeks and stayed with the owner for fifty years until it was bequeathed to the Boston Museum of Fine Arts. The simplicity of the design makes it very effective, but the water-color also conveys a sense of solitude and timelessness. The man, the boat, and even the water are still. The two verticals of the elderly mountain guide and the solid trunk of the old tree seem almost to bow toward each other. Homer was nearly sixty years old when he painted *The Adirondack Guide*. Perhaps he saw something of himself in both man and tree, who are so at home and at peace in their natural setting.

Teach

Tell students that Homer painted *The Adirondack Guide* when he was nearly sixty years old and that it reflects his lifelong interest in the outdoors, in water, and in everyday activities.

Ask students to identify the various colors Homer used in this watercolor. In what places are primary colors left pure? Where are they mixed? Where can students find the use of complementary colors? (green and red) Also have them identify the neutrals. Describe how the brighter colors and the neutrals balance each other.

Make sure students perceive the fluid use of wet paint. Point out the mix of wet colors that creates the blurry background and how this area sets off the more crisply painted figure. Ask students: What is unusual about the center of interest? (The face is at the exact center of the work.) How does Homer emphasize the face? (He contrasts it with the dark, dull color of the hat and frames it by the green bushes.) What does the artist do to keep the composition from being static? (He adds the horizontal oars to provide visual interest and to balance the vertical background tree.)

Explain that "reserving the lights" in watercolor is difficult because it means leaving white shapes to function as highlights. The painter must plan the location of these areas in advance and not paint there. Instead of doing that, Homer often blotted a color to lighten it. Sometimes he even scraped away the paint with a knife. The gray of the fallen tree behind the left oar was likely blotted out to lighten it. The highlights of the beard may have been created by scraping. Explain to students that scraping should only be done at the end because it disturbs the paper's surface; colors painted over scraped areas are absorbed differently.

Activity

Description: Students will use primary colors to create a watercolor painting.

Materials

- watercolors
- sketching paper
- watercolor paper
- pencil
- large wash and fine detail brushes
- paper towels or tissues for blotting
- X-acto knife or other scraper

Discuss: Describe to students the process of painting wet on wet. You may want students to practice this technique, as well as blotting and scraping, before they begin.

Procedure

1 Have students practice mixing primary colors to create secondary colors, complementary colors, and neutrals. Also have them explore dilution to create lighter and darker values.

2 Students should create thumbnail sketches to compose their painting and then sketch in the basic shapes on watercolor paper.

3 They should first wash in larger shapes using light colors. Blot out any highlights or lighter areas. Where appropriate have them allow colors to mix on the paper.

4 Students add medium values letting these wet colors mix with the lighter colors underneath. Blot away any undesirable or muddy mixes. Students should let the paint dry at this point.

5 They add darker values, rewetting areas as necessary. Let the paint dry again.

6 Students complete the work by adding any outlines, drybrush work, and details. Lastly, they may scrape away small white areas as highlights.

Assessment Checklist

Does the painting have:
- a variety of colors mixed from primaries?
- a range of values?
- areas of fluid wet on wet paint?
- highlights, either reserved, blotted, or scraped out?
- good craftsmanship, including an interesting composition and no muddy areas?

Above and Beyond

Have students paint two versions of the same still-life. One should be painted using only tints and tones (white and gray added to hues); the other using tones and shades (gray and black added to hues). Discuss and compare the different moods or feelings of the two.

Correlations

Chapter 4, Lesson 3, 4, or 5: page 84

Introduction

Color harmonies are color relationships that artists use for a variety of purposes. Colors opposite each other on the color wheel are called complementary colors. Colors next to each other on a color wheel are called analogous. A split complementary is the combination of a color plus the two colors on either side of its complement. Triadic harmony involves three colors equally spaced on the color wheel. If an artist uses only one color or hue, plus black and white, the work is said to be monochromatic.

Artists can also create emphasis and contrast or develop mood and feeling through the use of warm and cool colors. Red, orange, and yellow are warm colors, which appear to move forward in a design. They also make shapes seem larger. Blue, green, and violet are cool colors, which appear to recede. Cool colors make shapes seem smaller.

Context

In the early years of the twentieth century, social, economic, and political revolutions were occurring all over Europe. Many artists concluded that only the arts could bring people together and create enough understanding for there to be peace.

In 1911, two artists, Franz Marc and Vasily Kandinsky, founded a group known as "The Blue Rider." Marc had been born in Munich, Germany, in 1880. Kandinsky was an expatriate Russian, who had been born in 1866. The two men invited composers, writers, and other visual artists to join them in

creating work that they described as "spiritual." The Blue Rider was centered in Munich, but its international nature brought the group into contact with the Fauves, a group of Paris artists who were revolutionizing the use of color.

Marc always had great sympathy for animals and during the few years when he produced his masterworks, including *Playing Dogs* and *Red Horses*, animals were his models. Partially inspired by the Fauves, Marc used brilliant colors that he felt communicated the lives and the energy of cows, deer,

cats, and monkeys. His favorite subject, though, was the horse.

In early 1914, Marc began to paint nonrepresentational pictures in the manner of Kandinsky, but then World War I broke out. Marc fought in the war and was killed at the Battle of Verdun later that year. The Blue Rider movement had been too late to bring about peace among the European nations, but one member—Kandinsky—would live on to become one of the greatest and most influential artists of the century.

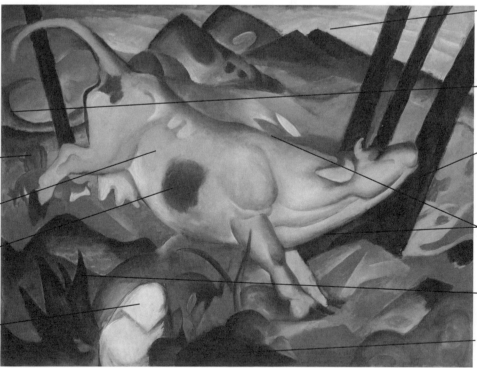

Franz Marc (1880–1916, Germany). *Yellow Cow (Gelbe Kuh)*, 1911. Oil on canvas, 55⅜" x 74½" (140.5 x 189.2 cm). Solomon R. Guggenheim Museum, New York. Photo by David Heald ©The Solomon R. Guggenheim Foundation, New York.

Cool colors of the mountains and sky contrast with the warm colors of the sun at right.

Curved lines make the landscape appear to move.

Darker values of the colors surrounding the cow help emphasize its importance.

Opposing diagonal lines create energy and frame the cow.

Flowing green plants.

Green of the grass provides contrast to the red field.

Distant grazing cows blend into the red earth.

Warm yellow makes the cow appear larger.

Blue spot on the cow helps break up the large shape and add visual interest.

White, rock-like oval shape helps to balance the cow's large diagonal shape.

Design Analysis

A lover of animals, Franz Marc had two pet deer and a dog, Russi. Farms and the local zoo provided him with additional models. Marc studied and drew these animals until he could render them accurately. He painted *Yellow Cow* in 1911, the year he helped to found The Blue Rider. His paintings capture the characteristic gestures of their subjects, but above all they are known for their color.

Marc corresponded with his artist friend August Macke about color. He did not believe that artists should be restricted to traditional ideas of color usage. He even disliked using complementary colors, because he thought they were too far from each other! To Marc, colors were symbols of psychological content. In a letter to Macke, he explained his ideas: "Blue is the male principle, stern and spiritual. Yellow the female principle, gentle, cheerful, and sensual. Red is matter, brutal and heavy and always the colour which must be fought and vanquished by the other two!"

In this painting, the yellow cow leaps across the picture seemingly full of energy and joy. The cow fills the foreground, with a few other cows quietly grazing in the background almost indistinguishable from the red land. The surrounding landscape seems to undulate with curved hills and flowing plants. The darker high-key colors surrounding the cow help to set it off. On either side diagonal black lines, which may represent trees or a broken fence, add to the dynamic energy of the composition. At the bottom a white rock-like shape helps to balance the cow's large diagonal shape. At right in the distance, the warm colors of a rising or setting sun contrast with the cool blues and violets of the mountains and sky.

Marc seems to invite the viewer to frolic along with his subject and share in the experience of an animal's simple existence. Strong front legs catch the cow's leap as she stretches her neck. She may even be mooing. If we use Marc's own theory about color, the cow may be seen as gentle and cheerful, and symbolic of the feminine. Perhaps her leap has removed her from the brutal and heavy red earth, to which the other cows seem so connected. By combining his psychological theory of color usage and his interest in animals, Marc has attempted to teach or remind us of the connection among all living things.

German archaeologists excavated the ancient city of Mycenae in Greece in the 1870s. Some art historians have suggested that Marc may have based the unusual shape of the cow on an animal figure that appears on an ancient cup unearthed at the site. If they are correct, would this add to or alter your feelings about the painting? Why?

Teach

Discuss with students that artists, like writers and poets, often use color symbolically. What symbolic colors can they identify? (Red for anger or love; blue or black for sadness; white for purity.) Explain that color can be symbolic whether the subject is depicted in an abstract style or realistically. Describe to students that Franz Marc developed a personal theory of color usage and share his thoughts with them.

Have students identify and categorize the colors found in *Yellow Cow*. How does the artist use primary and secondary colors? Where can they detect colors used to create contrast or emphasis? (The reds and greens of the landscape; the darker values that surround the lighter-valued cow.) Also have them point out the usage of warm and cool colors. (Warm colors for the cows, fields, and sun; cool for the mountains, plants, and sky.) What overall mood or feeling do they think the painting conveys? (Possible answers: warmth, fun, happiness) Help students see the small grazing cows in the middleground. Why might the artist have included them? (To flesh out the setting; to contrast with the leaping cow; to help viewers better read the middleground; for symbolic reasons.)

Help students appreciate the carefully structured composition of the painting as well. Have them identify the foreground, middleground, and background. What might the diagonal black lines represent? (trees; a broken fence) What role do they play in the design? (They complete the setting; add energy; help to frame the cow.) What does the white, rock-like shape contribute to the picture? You may need to cover it to help students realize its role. (It helps to balance the large diagonal of the cow.) Also ask volunteers to describe the surrounding shapes of the landscape. What do they convey? (Movement; energy; change)

Activity

Description: Students will create a painting that uses color symbolically. The work may be a landscape, figure, still-life, or portrait.

Materials

- sketch paper
- pencils
- acrylic or tempera paint
- paper or canvas

Discuss: Discuss the use of symbolic colors and remind students that an artist may also create personal meanings connected to colors. You may want to display a color wheel where all can refer to it.

Procedure

1 Encourage students to sketch a few possible compositions.
2 Students should make notes about what colors they will use. Will they employ a traditional color harmony, use warm or cool colors, or some other plan?
3 They should sketch the major shapes before they begin painting.
4 Remind students to paint the larger shapes first and to paint smaller shapes and details later. As they work, students should check their designs for balance, contrast, and visual interest, and make adjustments as necessary. Help them mix colors if necessary.

Assessment Checklist

Does the painting:
- use color symbolically?
- use color harmony, warm or cool colors, or some other plan?
- have an interesting composition?
- appear balanced?
- employ good craftsmanship: accurately rendered shapes or figures, neatly painted, unmuddied colors?

Above and Beyond

Some people have such strong associations for colors that they believe they can experience them with senses other than sight. The name for this trait is synaesthesia. Ask students to write their imaginative ideas for colors. How might the color green or the color purple taste? What might red sound like? How would blue feel? What smell might the colors yellow and orange have? Have students work singly and then share their thoughts.

Correlations

Chapter 4, Lesson 3, 4, or 5, page 84

5.1 Space

Touchstone North
Andy Goldsworthy

Introduction

In art, a design is either two-dimensional or three-dimensional. Architects and sculptors are those most likely to work with three-dimensional space, which has height, width, and depth. Three-dimensional structures have spaces that you can walk inside of or around.

Such structures combine both positive and negative space. The positive space is the object or structure itself. The negative space is the area surrounding that object or structure. In a building, the negative space is also the area inside the structure, but the division between inside and outside space is not always clear. Windows, for example, help make the exterior space flow through and become part of the interior. Such flowing space may also be present in a sculpture or other three-dimensional form constructed with wire or glass or pierced with holes.

Context

The sculptor Andy Goldsworthy grew up in Cheshire, England. He now lives with his wife and children in Penpont, Scotland, where he also has a studio. Goldsworthy uses materials from nature to create sculptures that seem to be a natural part of their environment or setting. Many of his works are even meant to decay over time. Sometimes, Goldsworthy takes photographs to document his sculptures and their disintegration. He has said: "My sculpture can last for days or a few seconds—what is important for me is the experience of making."

When in art school, Goldsworthy and other students rented summer cottages in a beach resort town after the vacationers had left. While there, Goldsworthy began creating sculptures on the beach. The weather and wind added elements of surprise to his work, and he liked that. He used rows of stones to create lines on the beach that disappeared and reappeared with the changing tides. Through photography, he could record the work as it changed over time. These "sculptures" defined the space of the beach and directed the viewer through it.

Goldsworthy states that his sculptures are not intended to improve on nature, but to enrich it "in the same way as a tree changes the place in which it grows." He spends time outside walking, looking, touching, and searching for ideas within the natural materials and spaces that he encounters. Before beginning a work, Goldsworthy uses drawings to help him explore his ideas and the materials. These drawings both help him to solve problems of structure and appearance and also to communicate his vision to possible patrons who might sponsor the project. His works include *Tree Spires and Sidewinder, Grizedale Forest* (1984–85); *Hooke Entrance, Dorset* (1986); and *Sheepfolds, Cumbria* (1996–2000).

Andy Goldsworthy
(b. 1956, England).
Touchstone North, 1990.
Environmental, Penpont.
©Andy Goldsworthy.

The axes of the stones all point to the negative space at the center.

The material adds texture and provides a sense of unity.

The circle frames and seems to contain the distant landscape.

Extra rocks create the sense of either a work-in-progress or a ruin.

The stone buttresses on either side add stability and force the viewer to look through the central opening.

The horizon line helps to define the space seen through the sculpture.

Patterns of light and shadow shift with changes in sky and weather.

The varied size and shapes of the stone add visual interest.

The open grassy area surrounding the piece both sets it off and invites the viewer to interact with the space immediately surrounding the sculpture.

Design Analysis

In 1989 Andy Goldsworthy spent four weeks in an Inuit village in Canada within the Arctic Circle. He wanted to learn the Inuit people's methods of working with ice and snow. He had worked with ice and snow before, but he liked the idea of working in a location where the ice would not melt. Near the North Pole, the artist and an Inuit assistant spent three days building four huge standing circles of ice blocks. Goldsworthy found it fascinating that each of the circles would face south, since that is the only possible direction when you are at the North Pole.

While in Canada, the artist devised a plan to create a fifth sculpture near his home in Scotland. This piece, made of stone, would be a kind of "touchstone" that would tie the two places together. Goldsworthy describes this fifth piece as "a landmark that will orientate north. North will be a part of its nature—possibly something that catches the north wind . . . that casts a north shadow or a window to the north."

The drawing shows Goldsworthy's design proposal for this fifth circle, called *Touchstone North*. It is drawn in graphite, with careful attention given to the shape of individual pieces and to the texture of the stone. The artist has worked with stone for many years and has a strong sense of its possibilities. The finished sculpture, seen in the photograph, seems to both rise up from the Scottish landscape and to frame this landscape within its center. There is an interesting contrast between the positive space of the sculpture, which seems so monumental and permanent, and the negative space, which changes fleetingly as the sun and clouds move around it.

Great buttresses of stone help to hold the circle of stone in place. These buttresses also block the views on either side of the structure and force the viewer to concentrate on the negative space at its center. The artist also included a seemingly random pile of stones in front of the circle. These stones may imply that the work is unfinished or perhaps that this circle is only a fragment of some ancient structure now in ruins. Someone coming upon it during a walk may wonder: What does this great circle sitting alone on a hill mean? Who made it and why? As a viewer wanders around the structure, these kinds of questions become part of the experience and help the viewer create her or his own meaning for the work.

Teach

Andy Goldsworthy sees his work as an effort to gain a greater understanding of nature. The viewer must study the natural materials, their relationship to the environment, and the changing effects of clouds, rain, snow, and sunlight. These are the same elements that the artist himself explores during the stages of drawing and planning. Some of his plans become realized sculptures, others do not.

Ask students to first describe the three-dimensional space of the finished piece. (It seems quite large; its width is greater than its height; its depth appears shallow.) Then have students discuss the relationship between the positive and negative space. (The positive space appears permanent and heavy; the negative space appears light and fleeting; the negative space is contained within the positive and surrounds it.) Explain that this complex relationship is at the heart of Goldsworthy's work. How do students think a person might react who casually encounters the sculpture while walking in the countryside? How might the piece appear during sunset, in the snow, on a cloudy day, from a distance, or surrounded by people?

Activity

Description: Students should draw a plan for a proposed sculpture to be built of natural materials and to be installed at a site in their community. The proposal must also include a written description of the piece.

Materials

- various graphite sticks, colored pencils, or pastels
- large drawing paper

optional:
- pen and ink

If possible, encourage students to take photographs of the site for the proposed piece.

Discuss: Remind students to give serious thought to the relationship between the negative and positive space of the piece. Also, explain that students can use scale (such as 1 inch equals 1 foot) to make their plans more accurate.

Procedure

1 Encourage students to brainstorm as many ideas as possible for their projects.
2 If possible, students should visit the proposed site and make drawings or take photographs.
3 They should write a few paragraphs that describe and explain the work and the ideas behind it. What might a viewer see and feel when he or she encounters the finished piece? You may have pairs of students read each other's proposals and make suggestions for improvement.
4 Students should sketch their plans and prepare a final drawing. Some students may wish to create two or three drawings to better show the three-dimensionality of the proposed work.

Assessment Checklist

Does the drawing:
- show the three dimensions of the piece?
- show the relationship between the piece and the site?
- have visual interest?
- convey the textures of the materials to be used?
- display good craftsmanship, such as neatness, clarity, and a sense of scale?

Is the written proposal:
- an accurate description and explanation the project?
- interesting and something that will prompt a reader to want to see the finished piece?
- well-written?

Above and Beyond

Have students visit a landscaped place and draw a plan of the three-dimensional space of the site. Have students attempt to capture the relationship between the positive and negative spaces. What paths does the eye follow from one space to the next? Does the site have a focal point or center of interest? If so, how can students convey or emphasize this in the drawing?

Correlations

Chapter 5, Lesson 1, page 96; Chapter 5, Lesson 5, page 104

5.2 Space

Distant Mountains
Lu Zhi

Introduction

Two-dimensional works of art have only height and width. Although they do not have actual depth, such works often create the illusion of depth on a flat picture plane. To achieve this, artists may choose from a variety of devices.

One of the most common ways to create a sense of depth in a drawing or painting is to use linear perspective. Linear perspective makes use of the fact that parallel lines seem to move away from the viewer and meet at a distant vanishing point. One-, two-, and three-point perspective systems set up grid structures to govern the relationships among all the elements of a design.

Since the Renaissance, Western artists have made extensive use of linear perspective.

Some nonlinear methods that artists use to create a sense of depth are position, overlapping, size variation, and the use of color or value. These simple devices are less rigid than linear perspective. They are commonly employed to create the illusion of depth in traditional Asian art.

Artists also can take advantage of a design's point of view to emphasize or manipulate the sense of space in a two-dimensional work.

Background is understood as faraway because of its placement toward the top of the picture plane.

Overlapping creates a sense of depth.

Mist may be ch'i, the breath of life.

Light color washes help to define forms in space.

Negative spaces connect all three grounds.

Diagonals lead the viewer's eye up through the space and into the distance.

Middleground is ambiguous. The open, negative space may be interpreted as river or body of water.

The trees here are much larger than those in the background.

The man and houses are insignificant compared to the vastness of nature.

Foreground is the area nearest the viewer.

Lu Zhi (1496–1576, China). *Distant Mountains*, c. 1540–50. Hanging scroll, ink and color on paper, 41½" x 12¼" (105.7 x 31.1 cm). W.L. Mead Fund, Photo ©1998 The Art Institute of Chicago. All rights reserved.

Context

During the Ming Dynasty of China (1368–1644 AD), there were two types of artists: the professional and the gentleman amateur. The professionals worked in studios and made a living from their work. The amateurs were well-educated men from aristocratic families whose wealth meant that they could choose not to work. Instead they might pursue their interests in history, music, poetry, calligraphy, or painting.

In traditional Chinese landscape painting, large open or negative spaces are an important part of the ideal design. The customary composition has three parts: the foreground, middleground, and background. These sections may be quite distinct and, unlike Western art, not strongly connected to each other.

Lu Zhi was a well-educated Chinese aristocrat who painted as a pastime rather than a profession. He was one of a group known as "literati" or scholar painters who were inspired by the painting masters of the past. The literati formed small groups to discuss their work and the creations of past masters. Their goal was to discover their own creative self-expression by understanding the earlier artists' styles. The literati painters preferred to avoid designs that would create strong emotional responses in a viewer. They believed that emotions were uncontrolled and immature. Many of them avoided scenes that were too pretty or beautiful, and some even tried to make their works ugly.

Design Analysis

The use of a master artist as a way to study art is traditional in both the East and the West. When a student copies a master's work, he or she is learning everything the

master included in the work. The master painter whose works Lu Zhi studied was Ni Tsan.

Ni Tsan usually painted landscapes in a vertical scroll format. His compositions included large areas of negative space. His style was to paint just a few things in the foreground; empty space, often depicting water, in the middleground; and mountains in the background. Ni Tsan also used as little ink as possible and added very little color in thin washes.

Look carefully at *Distant Mountains*, which Lu Zhi painted between 1540 and 1550. The lessons learned from Ni Tsan are evident in the vertical format, the large open areas of negative space, and the use of ink and thin washes of color.

The illusion of depth is created by using placement, overlapping, and size variation. The objects that make up the foreground are at the bottom of the painting. The background is at the top. The large negative space between them is the middleground.

The objects in the foreground are larger in size. The trees and rocky landscape predominate. The open area at left is a body of water on which we can see a man in a boat. The man and the few surrounding houses appear quite insignificant in relation to the overall design.

The negative space of the middle ground is somewhat ambiguous but is probably meant to be read as a river or other body of water. Notice how much of the composition is devoted to this open space and how it causes the foreground and background to seem disconnected from each other.

The objects that make up the background are smaller than similar objects in the foreground. Compare, for example, the heights of the trees. In the distance a tall mountain looms, overlapped at its base by smaller peaks.

As the viewer's eye moves from the foreground to the background, it follows a continuous zigzag of diagonals that roughly trace the course of the river. It starts at the lower left, moves to the houses at right and then to the smaller house and trees across the river on the left. The eye then cuts up across the middleground to the nearest trees and shoreline at the right. From here, it moves left to the lower peaks, then right along the river, and finally left and up toward the tallest and most distant mountain. As the viewer's eye follows these diagonals it moves further and further into the distance, creating a sense of almost infinitely receding space.

Of course, some of the objects depicted in the landscape also have symbolic significance that educated viewers would have understood. The mists at the base of the distant mountains may be interpreted as ch'i, the breath of life. And the man in the boat may be a stand-in for the scholar artist who contemplates the natural scene.

Teach

Explain that the representation of space in traditional Asian art is different from that in most Western art. The picture plane is sharply divided into foreground, middleground, and background. Make sure students realize that the foreground is at the bottom of the scroll and that the background is at the top. Help students perceive how the artist uses placement, overlapping, and variations of size or scale rather than linear perspective to create the illusion of depth. Have students compare the size of the trees in the foreground to those in the background. Also, ask students to point out examples of overlapping. (Trees in front of houses in the foreground; lower peaks in front of the tallest mountain).

Also point out the importance of open areas of negative space, which in this painting may be read as a continuous flowing river or body of water. Ask students how this negative space functions in the composition. (It seems to separate the foreground from the background, but also creates a series of diagonals that direct the viewer's eye into the distance.)

Make sure students understand that the artist, Lu Zhi, is following the ideals found in the work of a past Chinese Master, Ni Tsan, whom Lu Zhi admired. Explain that not only the composition but also the use of ink and light color washes were inspired by Ni Tsan.

Lastly, have students compare the sense of space to that commonly found in Western landscapes. How are they different? In what ways are they similar? You also may ask volunteers to offer possible interpretations of the painting. Why might the man be so small? (He is insignificant compared to the vastness and permanence of nature.) Who might he represent? (Possibly the artist himself, or he may simply represent humankind.)

Activity

Description: Students will create a series of ink paintings of the same scene to explore various methods of creating three-dimensional space on a two-dimensional surface.

Materials

- reference photos of various landscapes
- 9" x 12" or 12" x 18" drawing or rice paper (several sheets)
- ink (india or sumi)
- brushes (bamboo or watercolor)
- earth color (such as burnt sienna)

optional:
- watercolors for washes
- water containers

Discuss: Review the nonlinear methods used to create depth: placement, overlapping, size variation, value, and color. Explain that the goal is not to copy the photograph but to use different nonlinear methods to create a series of landscapes that have a similar sense of depth.

Procedure

1 Students select a photograph.
2 Encourage them to practice using brush and ink and diluting ink to achieve a range of values.
3 Students should make a few small, quick studies of possible compositions. Each one should use only one or two of the nonlinear methods.
4 They select the best compositions as the basis for the finished paintings.
5 Students create a series of at least three paintings. If the ink is waterproof, the watercolor washes can be put in after the ink. Otherwise those shapes must be done first.

Assessment Checklist

Do the paintings:
- recreate the landscape in a series of three?
- use varied nonlinear methods to create the illusion of depth?
- each have a foreground, middleground, and background?
- show good craftsmanship, such as accurately rendered shapes, visually interesting compositions, and avoiding muddy washes and unwanted smears or drips of ink?

Above and Beyond

Students may select two landscape paintings, one Western and one Eastern, and write a comparison of the way space is portrayed in each one. If adequate resources are not available, students may use *Distant Mountains* as the Eastern work.

Correlations

Chapter 5, Lesson 1, page 96; Lesson 6, page 104

Tribesman from the Mendi Area

Introduction

There are two types of texture in design: real and implied. Real texture is the actual surface quality of the work of art or object. A sculpture, for example, may have a rough or smooth, shiny or dull texture. When light hits an object, it strongly defines the texture of that object. At different times of day, the texture may seem to vary. In shadow or dim light, the surface texture is often reduced or imperceptible.

Artists use texture to add visual interest to a design. Raised or rough textures make a surface appear visually active. Smooth surfaces seem more quiet or restful. Within a design, artists can combine textures to create contrast, emphasis, or balance. Sometimes, artists include areas of minimum texture as a visual rest. A wide variety of materials can add texture to a design, and these textural effects can convey different messages and emotions.

Context

Papua New Guinea is a country in the southwest Pacific Ocean made up of a group of islands. More than 1,000 aboriginal tribes live among the islands, and each has its own traditions and language. The traditional costumes and body decoration of these peoples are a way of communicating information. Some elements identify the wearer as a member of a specific group. Others may signify rank or position.

The elaborate, colorful self-decoration used for rituals and celebrations often follows traditional guidelines. Some of the results may represent specific spirits or ancestors. Others may be examples of individual expression. Costumes may belong to a tribesmember or they may be borrowed or rented. Sometimes local people who trap birds for their plumage make costumes for others to use.

Malcolm Kirk is a photographer from Scotland who seeks out members of various cultures to record images of their costumes and body painting. "I myself have always been intrigued by the mutation of the individual image... Transformed by paint and plumage into masks, [these human faces] hover on that mysterious border separating the familiar from the obscure." When anthropologists question people about the meaning behind these costumes and paint, the reply is that they are just decoration. Kirk says that this need to analyze is not a part of the tribespeople's concern. By watching and studying the results over long periods of time, however, anthropologists have found similarities among cultures and have begun to assign meaning to certain elements.

Color and texture are added to shell plate necklace with red clay.

Colorful feathers from different birds may have been bought from a bird trapper.

Smooth enamel plate contrasts with the surrounding leaves and nearby feathers.

Cracked clay around the eyes adds visual interest.

Charcoal darkens and flattens the cheeks.

White clay accentuates the texture of the beard and the upper band of the apron.

Moss under collar adds padding and contrasts with shiny skin.

The skin is oiled to make it shine.

Cylindrical armbands are woven with a herringbone pattern.

Heavy chains make sounds as the dancer moves and contrast with other natural, lightweight materials.

Tribesman from the Mendi Area, New Guinea. Fuji Velvia. ©1999 Malcolm Kirk.

Design Analysis

In this photograph of a *Tribesman from the Mendi Area*, the costume and face painting is for either a traditional dance or ritual in which all men or the entire village may take part. All participants would be costumed for the special event.

A net wig forms the basis of this tribesmember's feather headdress. The feathers come from many different kinds of birds, and provide texture and strong contrasts of color to the overall design. The white forehead ornament is enameled metal, but traditionally this piece would have been made from shell. Its smooth, shiny texture is quiet and provides a contrast to the nearby feathers and to the three large leaves anchored behind it.

The man's face is darkened with powdered charcoal. The texture of the charcoal absorbs rather than reflects the light so that his cheeks seem flat rather than round. Paint applied over the charcoal and to his lips add color. Nowadays, some tribes use commercial paints rather than traditional colors made from natural substances. White clay helps to divide the man's face into separate shapes and accentuates the texture of his beard. As the clay around the eyes dries, it cracks and adds further visual interest to the face. The black cheeks and white area around the eyes make a dramatic background for the yellow and red shapes painted on the nose.

A soft-textured natural moss collar of green and brown adds emphasis to the large shell pendant worn like a necklace. The shell has been carefully polished and rubbed with red clay to create its variegated color and texture. The man has oiled his body and the resulting glow is intended to be a sign of good health. The smoothness and shine also contrast with the varied textures of many of the decorations.

The man wears a woven apron with tassels and chains. The white clay rubbed on the upper apron accentuates its weave. The heavy manufactured material of the chains also contrasts with the lighter natural materials of the apron. Seen up close, the wrist cuffs are even woven in a herringbone pattern.

When the costume is worn in a dance, certain elements may add movement or sound. The feathers and apron, for example, may sway and the chains clink against each other to produce sound. At night, while dancing in the firelight, the smooth and shiny materials and surfaces will appear to change as they reflect the colors and lights of the fire.

Teach

When we encounter a society whose methods of self-decoration are different from our own, people sometimes experience feelings of prejudice, confusion, or discomfort. It is important to remember that different cultures around the world have traditional methods of dress and decoration, and that many of these methods have counterparts even in contemporary Western cultures. For example, most societies use masks for festivals or theater performances. Face painting is similar to wearing a mask. Many individuals in Western cultures also use make-up, wear elaborate hats and jewelry, have tattoos, dye their hair, and wear unusual "costumes" for special occasions like weddings and graduation. Help students understand that when we look at things from another culture, we must try to appreciate and understand them.

Explain that the Mendi tribesman in this photograph is dressed for a very important occasion. Ask students to look carefully at the many materials that make up his costume. How many can students identify? (Feathers, leaves, clay, textiles, moss, chains, shell, oil) Have volunteers describe the various real textures that these materials provide. (Light, dry, cracked, woven, stringy, smooth, shiny) Have students identify ways in which these materials and textures provide visual interest, contrast with one another, and add emphasis to the costume design. Ask students to suggest how changing light and the wearer's movement may also alter the overall effect.

Have volunteers name special costumes or forms of self-decoration common among students, athletes, or other members of your school or community. (Badges, hats, and uniforms worn by athletes, band members, mascots, nurses, judges, crossing guards, clergy members, and even costumes for theatrical productions) You also may wish to tell them that among the Mendi people, the color black is thought to be masculine, red to be feminine, and white to mediate between the two. Discuss with students which materials, colors, and/or accessories are usually associated with men, with women, or used by both in various Western cultures.

Activity

Description: Students will use a variety of materials and textures to create a portrait or self-portrait.

Materials

- cardboard, mat board, or other rigid backing
- variety of textural materials
- pencils
- paper
- scissors
- glue, heavy tape

Discuss: Students must collect as many different materials as possible. They can trade with each other for greater variety of textures. Remind them that a balanced design usually includes areas of quiet or visual rest.

Procedure

1 Students should analyze and trade their collected materials and explore them for interesting textures, possible contrast, and colors.

2 They should sketch a plan for their composition, making notes for the placement and use of various materials. Students also must consider how they will successfully attach the materials to their chosen surface.

3 Students experiment with placing materials on a heavy backing according to their design. Keep checking for visual interest, balance, contrast, and areas of rest.

4 When students are satisfied with their design, they should securely attach the materials.

5 Each student should present his or her finished portrait to the class and explain the choices of materials and texture as well as the chosen subject.

Assessment Checklist

Does the finished work:
- use a wide variety of materials?
- include a wide variety of textures?
- employ contrast, balance, and visual interest?
- display good craftsmanship, such as an interesting composition, securely attached materials, and a sturdy backing?

Above and Beyond

Students may work in groups or as a whole class to investigate the use of various materials, accessories, and methods of self-decoration common in your school or community. If possible, have students organize a chart or photographic display of their findings.

Correlations

Chapter 6, Lesson 2, page 122

My Gems
William M. Harnett

Introduction

Unlike real textures, implied textures are either simulated or invented by the artist. Implied texture may be the roughness of a rock in a photograph or the fluffiness of a cloud in a painting. Creating implied textures in a realistic work requires careful observation. In order to depict them accurately, an artist must understand how light subtly acts on the materials and surfaces of various objects.

Implied textures are also used to provide visual interest in nonrepresentational works of art. In such works, textures may suggest feelings and moods, offer comparisons to familiar materials, or remain ambiguous. Textures and textural contrasts can also help unify a design or create pattern and movement.

Context

Traditionally, still-life painting was considered of lesser value than portraiture or paintings of historical and mythical scenes. The grand and heroic was believed to be the goal of the painter, not everyday objects. At the end of the nineteenth century, however, members of the middle class were looking for works to enhance their homes and to which they could relate. People at the time also had an appetite for realism and enjoyed the engravings that were widely published in newspapers and magazines.

William Michael Harnett was born in Ireland but emigrated with his parents to Philadelphia. He studied to be an engraver and then studied painting. Harnett is known for still-life painting, especially those called trompe l'oeil (fool the eye). The trompe l'oeil painters took realism a step further into deception. Their works were appreciated as technical accomplishments and works of art, but they also doubled as good jokes that deceived many viewers.

For a viewer to be deceived into thinking that a painting is real, certain guidelines had to be observed. Shallow scenes worked best, because the illusion of deep space is hard to create on a life-sized scale. All objects had to be painted their actual size. Carefully rendered textures and reflections were necessary to enhance the illusion. Of course, animals and people were not good subjects; painters could not recreate their constant movement. Sometimes trompe l'oeil painters did include dead birds and small animals as part of hunting scenes.

Owners often placed these paintings in a setting where the objects depicted seemed to be part of the room. For example, a painting of an open cupboard would be hung in a place where such a cupboard might be built into the wall. When the perfect spot was found, painter and owner alike would have

The music and books indicate an educated owner, but the subjects of heroes, betrayal, and revenge may have additional meaning.

Dull textures absorb light and create a feeling of warmth.

The dark ambiguous background blends in with the area where the work would have hung.

Highlights and shadows add to the illusion of reality.

The brass lamp is necessary to write or to read books and music at night.

Various implied textures provide contrasts of shiny and dull, hard and soft, light and heavy, smooth and rough.

Shaded rounded surfaces create a sense of volume.

Flute, pipe, and quill hint at popular leisure activities.

The carefully observed items seem well-worn and aged.

The tattered sheet of music seems to jut out from the picture plane.

William M. Harnett (1848–92, US). *My Gems*, 1888. Oil on wood, 18" x 13¾" (45.7 x 35 cm). Gift of the Avalon Foundation, ©1998 Board of Trustees, National Gallery of Art, Washington, DC.

the pleasure of surprising guests who would for a moment take the painting as real. Harnett's best works include *The Artist's Letter Rack* (1879), *The Old Violin* (1886), and *Still Life—Violin and Music* (1888).

Design Analysis

By the time William Michael Harnett painted *My Gems* in 1888, he was an accomplished trompe l'oeil painter. Unfortunately he did not write much about his paintings, and we know very few of his ideas about them. There are certain objects that appear repeatedly in his work, and sometimes the paintings even have themes hinted at by the books, sheet music, and letters contained within them. As a rule, Harnett's still-lifes tend to be quiet paintings that invite the viewer to sit and ponder them.

In *My Gems*, the artist follows the traditional rules for trompe l'oeil. He has collected everyday objects, placed them in a shallow setting, and depicted them actual size. The surfaces of the rounded blue-and-white delft jug at left and the brass lamp at right catch and reflect the light, which appears to be coming from the left. This light helps models the rounded forms and creates highlights on certain materials. It also throws shadows that provide an illusion of depth.

The number of implied textures in this work is remarkable. Along with the pottery and brass, there is paper, leather books, polished wood, cloth, and even a feather quill. Each one of these materials is carefully observed and distinct. Some of the objects, such as the cloth and leather books, seem to absorb rather than reflect the light. Especially fine is the brittle and slightly crinkled texture of the sheet music, which slightly juts out of the picture plane. The notes are even legible! Throughout, Harnett uses textures to create visual interest and contrast. Shiny materials are set against dull ones, smooth against rough, and soft against hard. Only the background of the still-life is not clear. It seems to resemble the wood grain of the box or chest on which the objects are displayed.

As in many of Harnett's works, this collection seems to describe a fictional person or family to which it might belong. First of all, such fine objects seem to signal that the owner has taste. But the worn nature of certain pieces, the old cloth with holes and burns, and the stained and tattered music tell us that these items are not new. Perhaps they are worn from much use or perhaps they hint that the owner is not wealthy or has fallen on hard times. A copy of Verdi's opera *Rigoletto* and works by Shakespeare signal that the

owner is educated and enjoys fine music and literature. The presence of flute, writing quill, and pipe also hint at leisure activities. Piecing these clues together, the viewer arrives at a kind of portrait of the missing owner, whose "gems" are displayed.

Harnett began his paintings with the background, with which he covered the canvas. Next, he depicted the items farthest back. Harnett would paint each object in its entirety even though parts of it would be covered by items in front! While some art historians speculate that the artist did preliminary drawings, none corresponding to his subjects have been found. From X-ray analysis, we do know that Harnett sometimes moved the location of objects in mid-painting, perhaps to refine the balance or emphasis of his composition.

Teach

Explain to students the guidelines that painters followed to create successful trompe l'oeil effects: objects portrayed actual size, shallow space, and accurately depicted textures and materials. Ask them to list the variety of implied textures found in the painting. How do they create visual interest and provide contrast? (Shiny against dull, hard against soft, heavy against light) Which objects do students think are the most realistic? Why? Have students examine the work up close. What small details has the artist added to make certain objects appear more life like? (Stains, tears, holes, worn edges)

Have students identify the direction of the light source (from the left) and locate corresponding highlights and shadows. Explain that by controlling the light source, Harnett could enhance the volume of the depicted forms. Given the exact nature of trompe l'oeil paintings, why do students think the background is dark and unclear? (To help the painting blend in once hung in a house.) Experiment with placing the reproduction in different places in the classroom. Are there some areas where it looks more real than others? Have students identify reasons why. (light source, background color or value, height, distance from viewer)

Explain that Harnett's paintings often seem to describe a fictional owner. What might the objects in *My Gems* tell the viewer about the possible individual or family to whom they belong? Ask students if they have had experiences with other works of art that appeared to be real but which proved to be fake. Can they describe the work and its setting? How did they feel when the work proved to be a photograph, painting, or

drawing? Did they enjoy being fooled? Why or why not?

Activity

Description: Students will attempt to create a trompe l'oeil work.

Materials

- still-life objects
- controlled light source
- colored pencils, pastels, or paint
- paper or canvas large enough for the objects to be depicted actual size

Discuss: Have students study and discuss methods and devices that can help an artist accurately create implied textures. Together, set up a shallow still-life for the class.

Procedure

1 Students should create a few thumbnail sketches to devise an interesting and balanced composition.

2 They lightly block in the objects on the paper or canvas.

3 Ask a partner to check the composition for accuracy.

4 Paint each item carefully, remembering to leave the background indistinct. Add appropriate highlights, shadows, and details of surface texture. Step back periodically to check the accuracy of the work.

5 Choose a suitable place to display the finished work.

Assessment Checklist

Does the work have:

- objects portrayed actual size and in great detail?
- shallow space and an indistinct background?
- a controlled light source that helps creates a sense of three-dimensionality?
- accurately rendered implied textures?
- good craftsmanship, such as realistically drawn objects, a balanced composition, no smudges, and a well-chosen place for display?

Above and Beyond

Small groups or the entire class may choose an area of the classroom or school (such as part of a room or wall), which they will then cover with a large trompe l'oeil painting that recreates the scene beneath. If possible, they should choose an area with controlled lighting and in which the painting will be viewed from a distance.

Correlations

Chapter 6, Lesson 3, page 122

Bibliography

LINE 1

Brett, David. *C.R. Mackintosh: The Poetics of Workmanship.* Cambridge, MA: Harvard University Press, 1992.

Kaplan, Wendy, ed. *Charles Rennie Mackintosh.* New York: Abbeville Press, 1996.

Robertson, Pamela. *Flowers: Charles Rennie Mackintosh.* New York: Harry N. Abrams, 1995.

LINE 2

Dumas, Ann; Ives, Colta; Stein, Susan Alyson; Tinterow, Gary; et al. *The Private Collection of Edgar Degas.* New York: The Metropolitan Museum of Art and Harry N. Abrams, 1997.

Growe, Bernd. *Edgar Degas 1834–1917.* New York: Taschen America, 1994.

Loyrette, Henri. *Degas: The Man and His Art.* New York: Harry N. Abrams, 1993.

SHAPE 1

Berrin, Kathleen, and Pasztory, Esther, eds. *Teotihuacan: Art from the City of the Gods.* San Francisco: Thames and Hudson, The Fine Arts Museums of San Francisco, 1993.

Pasztory, Esther. *Teotihuacan: An Experiment in Living.* Norman, OK: University of Oklahoma Press, 1997.

Schobinger, Juan. *The First Americans.* Grand Rapids, MI: William B. Eerdmans Publishing Co., 1994.

SHAPE 2

Haslam, Malcolm. *In the Nouveau Style.* Boston: Little Brown and Company, 1989.

Newark, Tim. *The Art of Emile Gallé.* London: Grange Books, 1989.

VALUE 1

Foote, Timothy, and the Editors of Time-Life Books. *The World of Bruegel c. 1525–1569.* New York: Time-Life Books, 1968.

Hartt, Frederick. *Art: A History of Painting, Sculpture, Architecture* Vol. 2. 4th ed. Paramus, NJ: Prentice Hall, Inc., 1993.

Old Master Drawings from the Albertina. Washington DC: International Exhibitions Foundation, 1984.

VALUE 2

Realism Today: American Drawings from the Rita Rich Collection. New York: National Academy of Design, 1987.

Strickler, Susan E., ed. *American Traditions in Watercolor: The Worcester Art Museum Collection.* New York: Abbeville Press, 1987.

COLOR 1

Cikovsky, Nicolai, and Kelly, Franklin. *Winslow Homer.* Washington, DC: National Gallery of Art, 1995.

Reed, Sue Welsh, and Troyen, Carol. *Awash in Color: Homer, Sargent, and the Great American Watercolor.* Boston: Museum of Fine Arts, and Bulfinch Press, 1993.

Robertson, Bruce. *Reckoning With Winslow Homer: His Late Paintings and Their Influence.* Bloomington, IN: Indiana University Press, 1990.

COLOR 2

Kandinsky, Wassily, and Marc, Franz, eds. *The Blaue Reiter Almanac.* New York: Da Capo Press, 1989.

Lindsay, Kenneth C., and Vergo, Peter, eds. *Kandinsky: Complete Writings on Art.* New York: Da Capo Press, 1982.

Partsch, Susanna. *Franz Marc 1880–1916.* New York: Taschen America, 1991.

SPACE 1

Beardsley, John. *Earthworks and Beyond: Contemporary Art in the Landscape.* 3rd ed. New York: Abbeville Press, 1998.

Goldsworthy, Andy. *Hand to Earth: Andy Goldsworthy Sculpture 1976–1990.* New York: Harry N. Abrams, 1993.

Goldsworthy, Andy. *Andy Goldsworthy: A Collaboration with Nature.* New York: Harry N. Abrams, 1990.

SPACE 2

Hutt, Julia. *Understanding Far Eastern Art: A Complete Guide to the Arts of China, Japan, and Korea.* New York: E.P. Dutton, 1987.

Pearlstein, Elinor L., and Ulak, James T. *Asian Art in the Art Institute of Chicago.* Chicago: The Art Institute of Chicago, 1993.

Silbergeld, Jerome. *Chinese Painting Style.* Seattle, WA: University of Washington Press, 1982.

TEXTURE 1

Kirk, Malcolm. *Man As Art: New Guinea*. San Francisco: Chronicle Books, 1993.

Liddell, Marlane. "Where Echoes of Spirits Still Dwell," *Smithsonian*. October, 1997, Volume 28, Number 7, p. 82ff.

Rainier, Chris. *Where Masks Still Dance*. Boston: Little, Brown and Company, 1996.

TEXTURE 2

Bolger, Doreen; Simpson, Marc; and Wilmerding, John; eds. *William M. Harnett*. Fort Worth: The Amon Carter Museum, 1992.

Frankenstein, Alfred. *The Reality of Appearance: The Trompe L'Oeil Tradition in American Painting*. New York: New York Graphic Society Ltd., exhibition 1970.

Notes